W9-BMD-415

REALISTIC TEXTURES

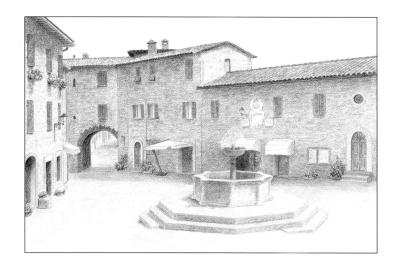

By Diane Cardaci

Walter Foster Publishing, Inc.
3 Wrigley, Suite A
Irvine, CA 92618
www.walterfoster.com

CONTENTS

INTRODUCTION

A pencil seems like a simple tool. It is inexpensive and portable, and no extensive training or high-tech equipment is required to use it. You've probably used one all your life and never thought much about it. Yet for those who wish to explore its versatility, the pencil can provide endless hours of enjoyment. A pencil's point can unleash a world of creative satisfaction. And although many artists may view it as a simple sketching tool, it also can be used to express the captivating textures of both the natural and manufactured worlds. A pencil can capture the fragile beauty of a butterfly's wing or the imposing form of a steel skyscraper. From the delicate lines created by a sharpened, hard lead point to the velvety, deep values of a soft graphite, the range of possibilities is infinite.

Over the years, my continuous fascination with texture has inspired me to use the pencil as a powerful tool of artistic expression. I have learned from teachers and fellow artists, as well as from studying the drawings of the Old Masters. Some of my favorite techniques, however, have come from just taking the time to experiment with hand position, pressure, the grade of the graphite, and different types of papers. This book is designed to share some tried-and-true techniques, as well as to inspire you to play with pencil textures. In addition to standard step-by-step lessons, I've also included creative exercises that focus on your artistic nature. Explore the world of textures and see what you can create on your own. See what your pencil is truly capable of and let it become a part of your creative palette. Enjoy!

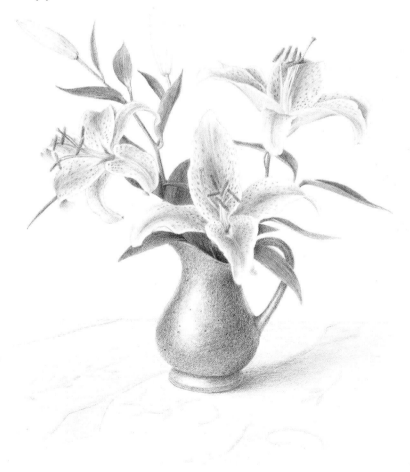

TOOLS AND MATERIALS

You can create almost any texture imaginable with a pencil and paper. You won't need a lot of supplies to follow the exercises in this book, but it's important to get acquainted with the basics. As you work, you can experiment with different tools to discover which ones suit you best.

Pencils

Pencils are labeled with numbers and letters. The letter indicates hard lead (H) or soft lead (B), and the number describes the grade—the higher the number, the more intense the hardness or softness of the lead. So a 9B is the softest of the B leads; a 2B is mildly soft. HB is in between hard and soft. Soft leads create thicker, darker lines; hard leads produce thinner, lighter lines.

There are several types of pencils to choose from: Woodless pencils feature larger leads that can form fine points; mechanical pencils create uniform strokes; carpenter's pencils create very wide strokes; water-soluble pencils produce washes that are similar to watercolor paint when manipulated with water; and lead holders are "sleeves" that can hold any grade of lead.

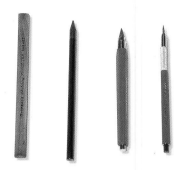

Choosing Your Pencil Pictured from left to right are a carpenter's pencil, a woodless graphite pencil, and large and small lead holders.

Papers

Your choice of paper is as important as your choice of pencil. I mainly use Bristol board, a heavy paper available in vellum (rough) or plate (smooth) finish. Rough, *cold-pressed* papers create a deeper tone and break up the stroke, which is great for drawing stone and landscape textures. Smooth, *hot-pressed* papers provide the ideal surface for delicacy and detail. The rougher the surface, the more "tooth" (or texture) the paper has. Use acid-free papers whenever possible to avoid yellowing and deterioration.

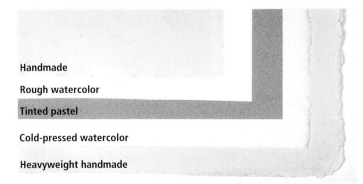

Handmade

Rough watercolor

Tinted pastel

Cold-pressed watercolor

Heavyweight handmade

Experimenting with Papers There is a great variety of papers you can choose from. Pictured from top to bottom are a small handmade paper, which has a deckle edge and is ideal for smaller drawings; a rough watercolor paper, which has a very rugged, but regular, pattern; a tinted pastel paper, which has a nice tooth; a cold-pressed watercolor paper, which is great for laying washes with water-soluble pencil; and finally a heavy-weight handmade paper, which has a very rough, irregular tooth.

Erasers

Erasers are great for creating highlights and for shading. I prefer kneaded erasers because they can be molded into different shapes and sizes to suit my needs. They're softer and more flexible than vinyl erasers, the type you usually see in schools. They are great for cleaning up a finished drawing because they don't leave crumbs.

Cleaning Up Pictured here are a battery-powered eraser, a kneaded eraser, vinyl erasers, and a pen eraser.

Sharpeners

Carpenter's pencils and other specialty pencils can be sharpened manually with a single-edge blade and/or a sandpaper block. Mechanical pencils have special sharpeners for the leads, called "pointers." For my wood pencils, I usually use an electric sharpener. Most artists use a combination of all these sharpeners, depending on the type of point they want. A mechanical sharpener will give you a very fine point, but you have little control over it. Sandpaper can make some nice blunt points that are difficult to create with other types of sharpeners. Some artists even use a utility knife to whittle their pencils into hard, sharp shapes.

Sharpening Your Tools Each type of pencil has a specific sharpener. If you're using a carpenter's pencil, you can find a blade and sandpaper at the hardware store. When you're done sharpening, the shavings can be used as graphite powder, also called "carbon dust."

Blending Tools

There are several tools that can be used to smudge and blend graphite. A *blending stump* is a rolled piece of paper that can be used for blending so you don't get your fingers dirty. A *tortillon* is similar, but shaped differently. When you're working with a larger area, you can use a chamois cloth for blending. These are important to have on hand for creating certain textures.

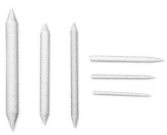

Blending Tools Made of tightly wrapped paper, tortillons are pointed on one end (right), whereas blending stumps are pointed on both ends (left).

Supporting Your Art

A sturdy drawing surface is invaluable. Portable drawing boards are very convenient and can be used at most tables. I currently do most of my fine art at an easel because it enables me to look at the piece from a distance to see how the work is progressing. I also use a large drawing table when I need more space.

Accessories

Rulers and triangles are indispensable for highly realistic buildings and other hard-edged subjects. Artist's drafting tape is a necessity for keeping your art in position, but do not tape within the drawing area, as this can leave residue.

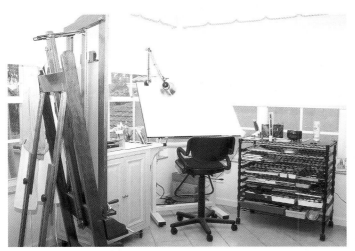

Organizing Your Workspace It's important to have a comfortable chair to work in, or you may hurt your back. You don't want to strain your eyes either, so make sure you have sufficient lighting. I prefer all my supplies to be within arm's reach at all times so I don't have to interrupt my drawing to go look for something.

Eraser Shields and Stencils Another great tool is the eraser shield (above), which acts as a stencil when erasing parts of your drawing. You also can use stencils to help you create perfect corners and curves.

HANDLING THE PENCIL

You can create an incredible variety of effects with a pencil. By using various hand positions, you can produce a world of different lines and strokes. If you vary the way you hold your pencil, the mark the pencil makes changes. It's just as important to notice your pencil point. The point is every bit as essential as the type of lead in the pencil. Experiment with different hand positions and pencil points to see what your pencil can do!

I use two main hand positions for drawing. The writing position is good for very detailed work that requires fine hand control, as well as for texture techniques that require using the point of the pencil. The underhand position allows for a freer stroke with more arm movement—the motion is almost like painting. (See the captions below for more information on using both hand positions.)

Using the Writing Position The writing position is exactly what it sounds like! Hold the pencil as you normally do while writing. Most of your detail work will be done this way, using the point of the pencil.

Using the Underhand Position Pick up the pencil with your hand over it, holding the pencil between the thumb and index finger; the remaining fingers can rest alongside the pencil. You can create beautiful shading effects from this position.

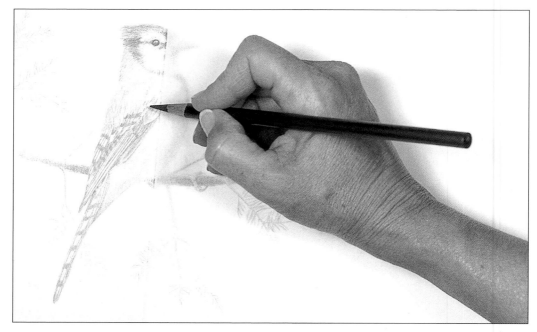

Protecting Your Art It's a good idea to use a piece of tracing paper as a barrier between your hand and your drawing. The tracing paper not only prevents you from smudging your drawing, but it also keep oils from your skin from damaging the art.

PRACTICING LINES

When drawing lines, it is not necessary to always use a sharp point. In fact, sometimes a blunt point may create a more desirable effect. When using larger lead diameters, the effect of a blunt point is even more evident. Play around with your pencils to familiarize yourself with the different types of lines they can create. Make every kind of stroke you can think of, using both a sharp point and a blunt point. Practice the strokes below to help you loosen up.

As you experiment, you will find that some of your doodles will bring to mind certain imagery or textures. When I make little Vs, I think of birds flying. When I make wavy lines, I begin to see water.

Drawing with a Sharp Point First I draw a series of parallel lines. I try them vertically; then I angle them. I make some of them curved, trying both short and long strokes. Then I try some wavy lines at an angle and some with short, vertical strokes. I also have fun making a spiral and then try grouping short, curved lines together. Then I practice varying the weight of the line as I draw. Little Os, Vs, and Us are some of my favorite alphabet shapes.

Drawing with a Blunt Point It is good to take the same exercises and try them with a blunt point. Even if you use the same hand positions and strokes, the results will be different when you switch pencils. Take a look at my examples. I drew the same shapes with both pencils, but the blunt pencil produced different images. My favorite blunt-point tool is a 6B large-diameter lead that I use with a lead holder.

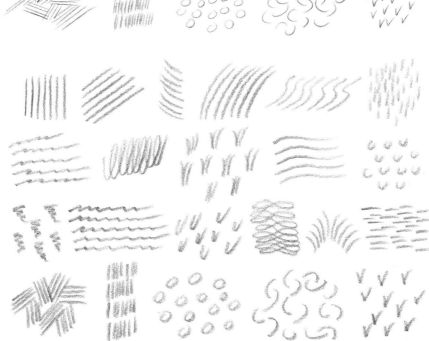

"PAINTING" WITH PENCIL

When you use painterly strokes, your drawing will take on a new dimension. Think of your pencil as a brush and allow yourself to put more of your arm into the stroke. To create this effect, I usually hold my pencil between my thumb and forefinger and use the side of the pencil. (See page 6.) If you rotate the pencil in your hand every few strokes, you will not have to sharpen it as frequently. The larger the lead, the wider the stroke will be. The softer the lead, the more painterly an effect you will have. These examples were all made on smooth paper with a 6B pencil, but you can experiment with rough papers for more broken effects.

Starting Simply First I experiment with vertical, horizontal, and curved strokes. I keep the strokes close together and begin with heavy pressure. Then I lighten the pressure with each stroke.

Varying the Pressure Here I randomly cover the area with tone, varying the pressure at different points. I continue to keep my strokes loose.

Using Smaller Strokes I make small circles for the first example. This reminds me of leathery animal skin. For the second example (at far right), I use short, alternating strokes of heavy and light pressure, similar to a stone or brick pattern.

Loosening Up At right, I use vertical strokes. Varying the pressure for each stroke, I start to see long grass. At the far right, I use somewhat looser movements that could be used for water. First I create short spiral movements with my arm (above). Then I use a wavy movement, varying the pressure (below).

FINDING YOUR STYLE

Many great artists of the past can now be identified by their unique experiments with line. Van Gogh's drawings were a feast of calligraphic lines; Seurat became synonymous with pointillism; and Giacometti was famous for his scribble. Can you find your identity in a pencil stroke?

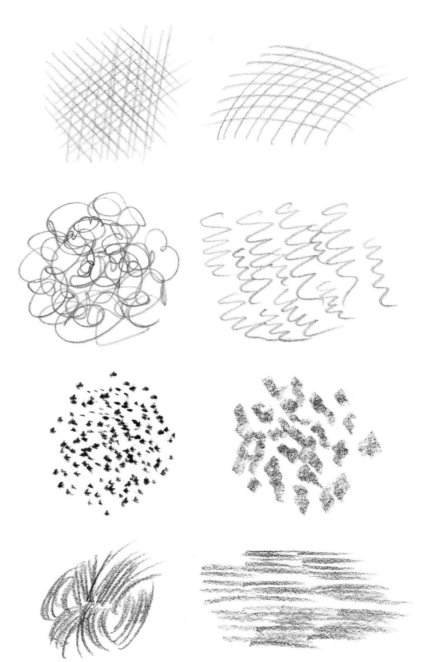

Using Criss-Crossed Strokes This technique is commonly referred to as "crosshatching." If you like a good deal of fine detail in your work, you'll find that crosshatching allows you a lot of control. You can adjust the depth of your shading by changing the distance between your strokes.

Sketching Circular Scribbles If you work with round, loose strokes like these, you are probably very experimental with your art. These looping lines suggest a freeform style that is more concerned with evoking a mood than with capturing precise details.

Drawing Small Dots This technique is called "stippling"—many small dots are used to create a larger picture. Make the points different sizes to create various depths and shading effects. Stippling takes a great deal of precision and practice.

Simulating Brushstrokes You can create the illusion of brushstrokes by using short, sweeping lines. This captures the feeling of painting but allows you the same control you would get from crosshatching. These strokes are ideal for a more stylistic approach.

WORKING WITH DIFFERENT TECHNIQUES

Below are several examples of techniques that can be done with pencil. These techniques are important for creating more painterly effects in your drawing. Remember that B pencils have soft lead and H pencils have hard lead—you will need to use both for these exercises.

Creating Washes Create a watercolor effect by blending water-soluble pencil shading with a wet brush. Make sure your brush isn't too wet, and use thicker paper, such as vellum board.

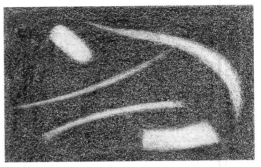

Lifting Out Blend a soft pencil on smooth paper, and then lift out the desired area of graphite with an eraser. You can create highlights and other interesting effects with this technique.

Rubbing Place paper over an object and rub the side of your pencil lead over the paper. The strokes of your pencil will pick up the pattern and replicate it on the paper. Try using a soft pencil on smooth paper, and choose an object with a strong textural pattern. For this example, I used a wire grid.

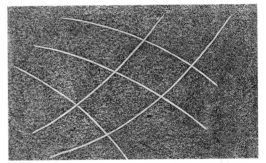

Producing Indented Lines Draw a pattern or design on the paper with a sharp, non-marking object, like a knitting needle or skewer, before drawing with a pencil. When you shade over the area with the side of your pencil, the graphite will not reach the indented areas, leaving white lines.

Smudging

Smudging *is an important technique for creating shading and gradients. Use a tortillon, blending stump, or chamois cloth to blend your strokes. It is important to not use your finger, because your hand, even if clean, has natural oils that can damage your art.*

Smudging on Rough Surfaces
Use a 6B pencil on vellum-finish Bristol board. Make your strokes with the side of the pencil and blend. In this example, the effect is very granular.

Smudging on Smooth Surfaces
Use a 4B pencil on plate-finish Bristol board. Stroke with the side of the pencil, and then blend your strokes with a blending stump.

Combining Techniques

Various techniques can be combined to create very unique effects. By experimenting with them, you can see how many different effects you can create by just changing your pencil, the amount of pressure you place on the pencil, or your hand position. For example, making an indented line and applying tone over it is a great way to show the fine veins of a leaf. By letting loose, you may come across an accidental technique that is perfect for what you are trying to express.

Crosshatching and Stippling I use the side of a 2B pencil, and quickly stroke back and forth across the page in a zigzag manner. Next I take a sharp HB and create cross-hatched lines on top. I switch to a large lead holder with a 6B lead and use heavy pressure to put some stipple on top. This effect reminds me of a chain link fence covered by flowers.

Indentations and Water Before I make any marks with the pencil, I use a knitting needle to make impressions in the paper. Then I use the side of a water-soluble pencil to lay down some tone. Next I take a wet watercolor brush and smear the graphite. This technique is very useful when you want to create a scratchy, rough look, such as old leather or weathered metal.

Smearing and Lifting Smudging is a great technique for rendering softer textures, such as fur. I use a soft 6B pencil to make some horizontal strokes and then lightly smear them with a blending stump. On top of this, I place some very heavy, curved, short strokes. Then I use my kneaded eraser to lift out random spots of graphite. This texture is reminiscent of a nubby sweater.

Using Textured Paper and Soft Pencil Here you can see how rough paper combined with a soft pencil creates the appearance of rocky dirt. I use a vellum paper and draw with the side of a 6B. I put down heavy tone and dab a few spots with my kneaded eraser, but I don't have to worry much about texture because the paper is creating it for me. Then I use a sharp 2B to draw a few individual rocks. I evoke the feeling of a gravelly road without adding much detail.

UNDERSTANDING VALUE

One of the main challenges of drawing is making a flat, two-dimensional image look like a three-dimensional object—you can do this by including variations in value in your drawings. *Value* refers to the relative lightness or darkness of a color or of black. By shading (adding dark values) and highlighting (adding light values), you produce the value variations which create the illusion of depth.

Working with Value Scales

Just as a musician uses a musical scale to measure a range of notes, an artist uses a value scale to measure changes in value. You can refer to the value scale so you'll always know how dark to make your dark values and how light to make your highlights. The scale also serves as a guide for transitioning from lighter to darker shades.

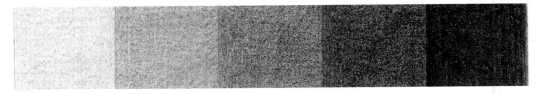

Creating a Value Scale Making your own value scale will help familiarize you with the different variations in value. Work from light to dark, adding more and more tone for successively darker values.

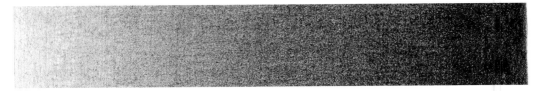

Blending Values Now create a blended value scale—use a blending stump to smudge and blend each value into its neighboring value from light to dark. This will show you how one value blends into the next as they gradually get darker.

Creating Form with Light

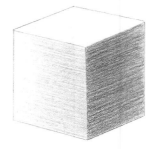

Every shape or form we see is created by the reaction of the object's surface to light. In order to create a strong three-dimensional quality, the subject must be lit in a way that brings out its form. For example, if you light an object from the front, you won't see the shadows that fall across the form, and it will appear to be flattened. If you light the object from a three-quarter angle, the object will produce shadows, and the transition in values will accentuate the dimensions of the form.

There are two main types of shadows: form shadows and cast shadows. *Form shadows* are the shadows that are on the surface of the object itself—these shadows give an object a sense of depth. Form shadows are dependent on the lighting source for your object; they get darker as they move away from the light. *Cast shadows* are the shadows that the object throws onto other surfaces. (Think of the shadow cast by a tree on a sunny day.)

Adding Depth with Light Here you can see value at work. By shading the sides of this object, I have created the appearance of depth. Making one side of the cube dark and the other light makes it seem that each side is in a different space. As you can see, the direction of my strokes follow the form of the object.

FOLLOWING FORM

In addition to creating form, light also creates the texture of an object. As the light falls across an object with a strong texture, each individual aspect of the texture will create its own light and shadow effect. But these individual value changes must remain secondary to the form shadows, or the form will be lost. For example, if you draw a very thick texture all over an object and forget to include highlights to show the object's shape, the object will appear to be flat and without depth.

When you are drawing an object with texture, first imagine it as a smooth object with no texture at all. I like to think of the texture of the object as a sort of translucent coat, so the underlying values of the form will show through. It is good practice to draw a few textured objects and develop a light, middle, and dark value for each of the objects. Then look at how the form changes as the values change.

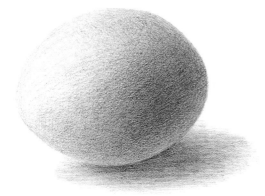

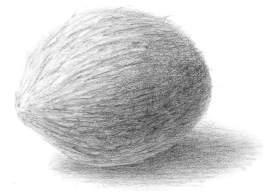

Seeing Form A coconut (shown above as being lit from a three-quarter angle) has a form similar to that of an egg. I imagine the coconut with a smooth, egglike surface. Once I understand the way the light is hitting the object, I can draw its form.

Form vs. Texture A coconut is a good example of texture versus form. You might be tempted to use dark, heavy shading to portray the coconut's surface. However, in this case, the coconut's form is more important than its texture.

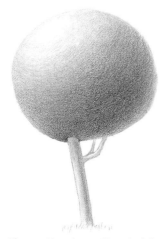

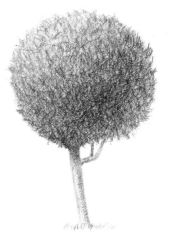

Studying Shapes To understand how the light source creates the form of this tree, I break down the tree into a ball and a cylinder. I use rough paper to add some texture, and I put down a layer of dark tone with the side of the pencil.

Adding Detail Using short strokes, I create the leaves. Don't get caught up in drawing individual leaves—instead suggest the leaves with a pattern of texture. As I draw the leaves, I leave the texture lighter on top where the light source hits the tree.

ADDING TEXTURE WITH LIGHT

When creating textures in a drawing, keep in mind that a drawing is more dynamic when something is left for the imagination—you don't have to draw every little leaf or stone. It's okay to lose some of the texture in shadows and bright spots of light.

Another important aspect of creating texture is the shape of the highlights. Highlights play a major role in determining whether an object is shiny or dull. Shiny objects have sharp-edged highlights, whereas dull or soft-textured objects have soft-edged, blurred highlights.

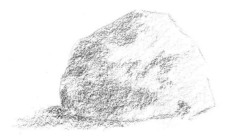

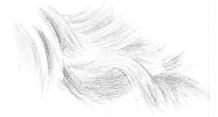

Portraying Stone I quickly outline the rock on vellum Bristol, which has a rougher finish. I start with the side of a 4B and lightly lay down some strokes to create a base of texture. I add a few fine lines where there are some sharp edges and shadows. I then finish by randomly stippling with a broad-point 6B pencil. This helps give the rock a craggy, uneven appearance.

Depicting Fur I use an HB pencil to establish the direction of the fur with the direction of my pencil strokes. Real fur is not uniform in length, so I vary these strokes. I begin to lose some of the detail in the darker areas. This adds natural-looking shadows and light. I make sure my edges follow the soft, flowing texture of the subject.

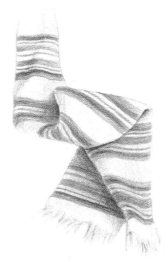

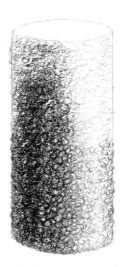

Creating Softer Forms A scarf is made of a soft, dull material, so I have to be sure that I use soft highlights. Sharp highlights would make the scarf appear hard and shiny. I start off this drawing with an accurate outline of the scarf and its stripes. I use the side of a 2B pencil to draw the main light and shadow values of the form. My strokes follow the form of the folds in the scarf. In the deep folds of the scarf, I intentionally lose much of the tonal differences in the stripes.

Shading Uneven Surfaces I create an outline using a broad 6B, and I shade all over the form with circular strokes. These small circles create the rough, pebbly texture. Because the object is bumpy, I'm not too concerned about staying within the outline. I fill in the shadows, remembering that the light follows the pole's curve as it moves across the cylindrical form, creating a soft transition. I use a sharp 4B and make small, circular strokes to add more pebbles. I keep the most distinct pebbles in the lighter regions and lose some of the texture in the darkest parts.

DEPICTING DISTANCE

In nature, impurities in the air—such as moisture and dust—block out some of the wavelengths of light, making distant forms appear less detailed. As objects recede into the distance, they begin to lose their sharp edges, as well as their texture. This phenomenon, known as "atmospheric perspective," gives you an additional tool to create depth in your drawings. You can further create the illusion of depth by making foreground objects larger and more detailed than background or distant objects.

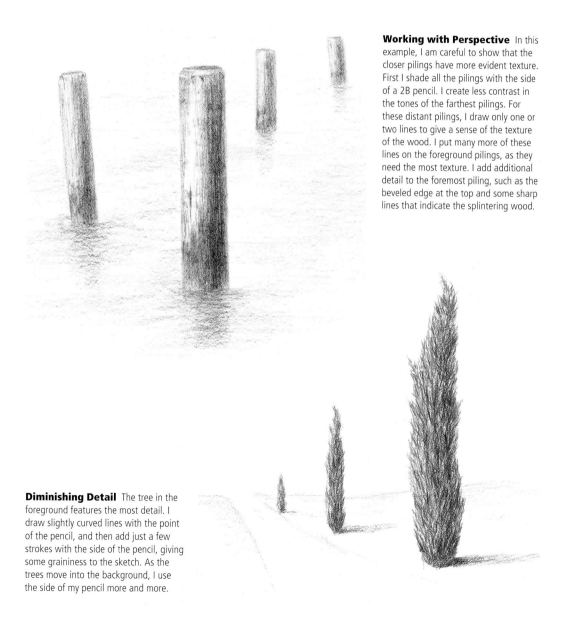

Working with Perspective In this example, I am careful to show that the closer pilings have more evident texture. First I shade all the pilings with the side of a 2B pencil. I create less contrast in the tones of the farthest pilings. For these distant pilings, I draw only one or two lines to give a sense of the texture of the wood. I put many more of these lines on the foreground pilings, as they need the most texture. I add additional detail to the foremost piling, such as the beveled edge at the top and some sharp lines that indicate the splintering wood.

Diminishing Detail The tree in the foreground features the most detail. I draw slightly curved lines with the point of the pencil, and then add just a few strokes with the side of the pencil, giving some graininess to the sketch. As the trees move into the background, I use the side of my pencil more and more.

BOTANICAL TEXTURES

Botanical drawings are portraits of plants that are drawn with realism. They show the beauty of flowers and other plants with their intricate and delicate detail.

Flowers make great subjects because the bright colors challenge you to create tones that evoke their vivid nature. However, botanical compositions contain more than just flowers. Trees and other flowerless plants make wonderful subjects as well.

When drawing plants, it is important to remember that leaves come in many shapes, sizes, and textures. Besides their general shape, their edges (irregular or smooth), shininess (glossy or matte), and thickness must be carefully observed. It can be quite interesting to capture the unique qualities of each plant. So don't just stop and smell the roses—pull out your pencil and sketch them!

Petals

Step 1 I draw the outline of the petal, then add the general shape of the coloration, some of the darker spots, and the raised center area. The strokes emphasize the petal's softness.

Step 2 Next I darken the irregular spots and deepen the area along the center of the petal to bring out the raised parts.

Parts of a Flower

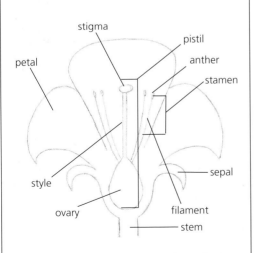

stigma

pistil

petal

anther

stamen

style

sepal

ovary

filament

stem

Flower Detail A flower is made up of more than just petals and leaves. There are many small details that you should be familiar with to be able to bring realism to your art. This diagram shows the different parts of a flower that will be referred to in some of the step-by-step lessons; this diagram also will help you in your future sketches.

Step 3 I deepen the shading of the colored areas, using long strokes that follow the direction of the petal and bring out its smoothness. I darken the markings and the center line, and then I lightly shade the area where the petal folds back on itself.

Leaves

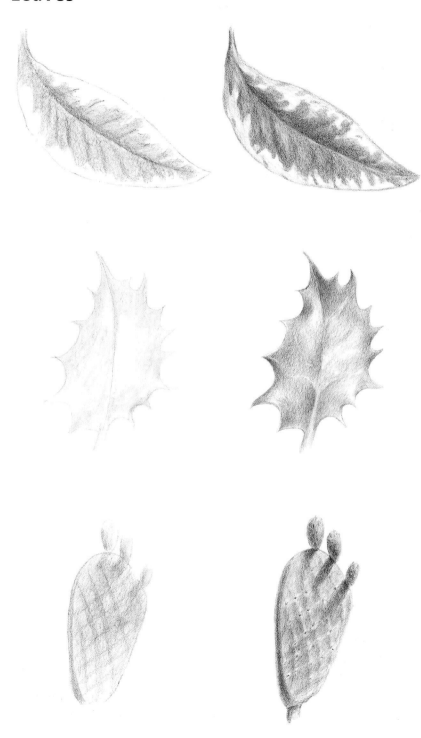

Croton Leaf The challenge here is to capture the hard surface and lovely variations in color with graphite. I outline the major patterns (far left), and then I draw in the deepest values with a 2B. I blend the tone, maintaining the values that indicate the color changes. I lift out the details along the edge (left).

Holly Leaf With the side of a 2B, I lay in some tone (far left). I smudge the tone and lift out any areas that should remain white. The highlights will be important for creating the appearance of this leaf's glossy shine. I add deeper tones with a 4B (accenting the sharp points of the leaves and the raised veins), and then I blend. I lift out the lighter veins (left).

Cactus Leaf The dark shading along the edge of this leaf defines its thickness (far left). I add the shadows cast by the cactus fruit. I shade the diamond-shaped depressions on the leaf with a 2B, and I lift out the raised areas. I place dots to emphasize the points where the sharp spines connect to the cactus (left).

BELLFLOWER

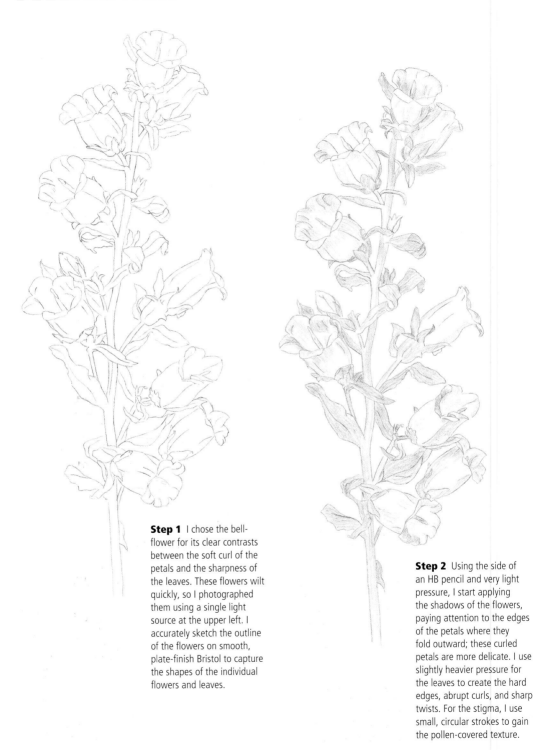

Step 1 I chose the bell-flower for its clear contrasts between the soft curl of the petals and the sharpness of the leaves. These flowers wilt quickly, so I photographed them using a single light source at the upper left. I accurately sketch the outline of the flowers on smooth, plate-finish Bristol to capture the shapes of the individual flowers and leaves.

Step 2 Using the side of an HB pencil and very light pressure, I start applying the shadows of the flowers, paying attention to the edges of the petals where they fold outward; these curled petals are more delicate. I use slightly heavier pressure for the leaves to create the hard edges, abrupt curls, and sharp twists. For the stigma, I use small, circular strokes to gain the pollen-covered texture.

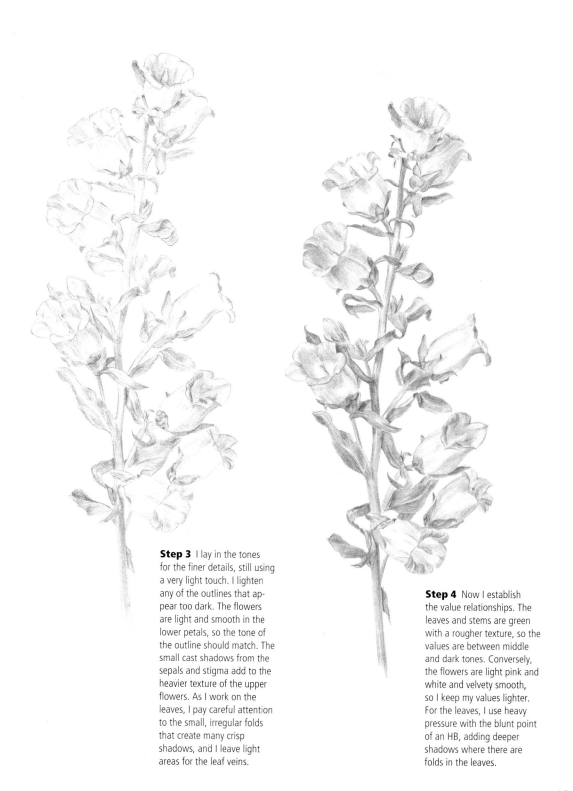

Step 3 I lay in the tones for the finer details, still using a very light touch. I lighten any of the outlines that appear too dark. The flowers are light and smooth in the lower petals, so the tone of the outline should match. The small cast shadows from the sepals and stigma add to the heavier texture of the upper flowers. As I work on the leaves, I pay careful attention to the small, irregular folds that create many crisp shadows, and I leave light areas for the leaf veins.

Step 4 Now I establish the value relationships. The leaves and stems are green with a rougher texture, so the values are between middle and dark tones. Conversely, the flowers are light pink and white and velvety smooth, so I keep my values lighter. For the leaves, I use heavy pressure with the blunt point of an HB, adding deeper shadows where there are folds in the leaves.

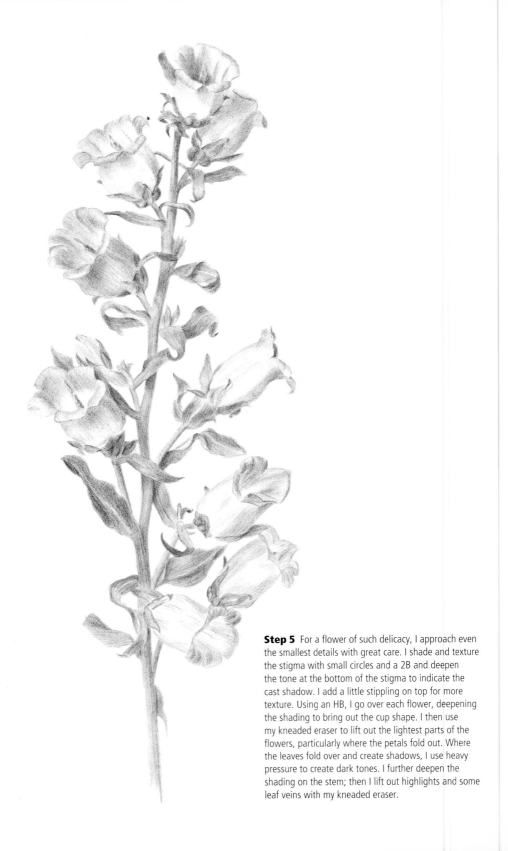

Step 5 For a flower of such delicacy, I approach even the smallest details with great care. I shade and texture the stigma with small circles and a 2B and deepen the tone at the bottom of the stigma to indicate the cast shadow. I add a little stippling on top for more texture. Using an HB, I go over each flower, deepening the shading to bring out the cup shape. I then use my kneaded eraser to lift out the lightest parts of the flowers, particularly where the petals fold out. Where the leaves fold over and create shadows, I use heavy pressure to create dark tones. I further deepen the shading on the stem; then I lift out highlights and some leaf veins with my kneaded eraser.

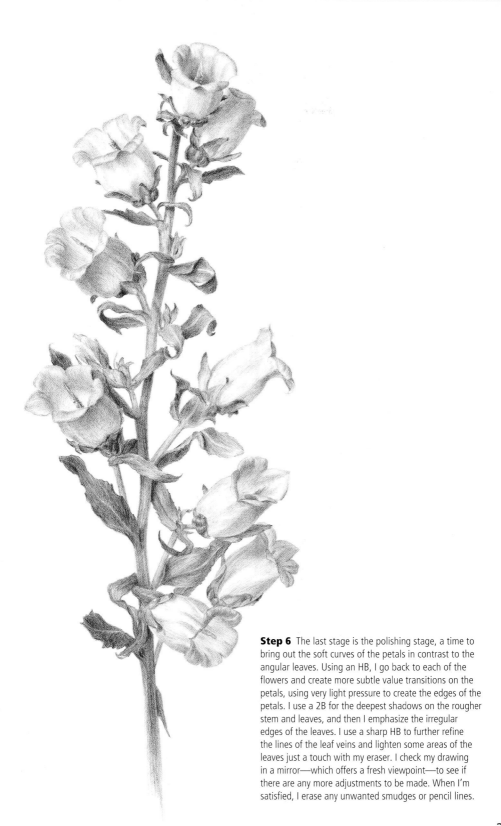

Step 6 The last stage is the polishing stage, a time to bring out the soft curves of the petals in contrast to the angular leaves. Using an HB, I go back to each of the flowers and create more subtle value transitions on the petals, using very light pressure to create the edges of the petals. I use a 2B for the deepest shadows on the rougher stem and leaves, and then I emphasize the irregular edges of the leaves. I use a sharp HB to further refine the lines of the leaf veins and lighten some areas of the leaves just a touch with my eraser. I check my drawing in a mirror—which offers a fresh viewpoint—to see if there are any more adjustments to be made. When I'm satisfied, I erase any unwanted smudges or pencil lines.

TRADITIONAL STILL LIFE TEXTURES

Still life compositions allow you to have complete control: You design the composition; choose the range of textures, values, and colors; and create the ideal lighting situation. I like to set up my compositions so that there are many contrasting textures, such as a smooth piece of fruit in a coarsely woven basket. Play around with different types of fruits and cheeses to see how the light catches their textures. It's always an added bonus to be able to share your food subject after your drawing is done!

Fruit

Apple A polished red apple reflects a strong highlight, which contrasts with the skin's dark tone. I apply carbon dust (shavings I collected from sharpening my pencils) with circular, irregular strokes (top), then lift out the highlight with an eraser (bottom).

Orange First I apply carbon dust, using strokes that follow the fruit's form (top). I lift out the main highlight and then use an eraser to create curved strokes around the highlight, showing the bumpy texture of the orange's skin (bottom).

Strawberry I lay in dark tone with carbon dust and use a 4B to start establishing a dotted pattern for the strawberry (top). I continue to enhance the dimpled, seeded texture by adding thin, curved highlight lines around the darker dots (bottom).

Cantaloupe With the side of a 4B, I lay down some tone and then randomly blend the graphite. I lift out a few lines to see how the lights contrast with the dark tone (top). Because the skin is very rough, there are no highlights—just the upper veining.

Baskets

▶ **Weaves** Baskets are incredibly tactile. The texture of the weave creates a three-dimensional pattern with many layers. Trying your hand at rendering a woven basket is a great way to learn about the interplay of light and shadow and how it can show the heavy texture of the basket.

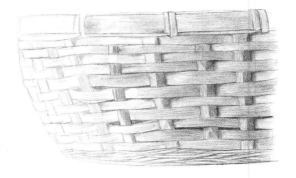

Wood

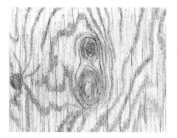

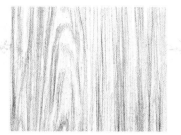

Knotty Pine Zigzagged lines create the rough pattern of the grain. I use concentric ovals to draw the knots. Then I use an HB to add light, straight vertical strokes and individual shorter strokes to show the raised grain.

Ash For this fine-grained wood, I make long, inverted U shapes with a slightly uneven motion. Then I draw very long grain lines, varying their density and allowing the lines to curve naturally. I go over these lines with light, vertical lines.

Zebrawood With a 4B, I create the dark lines of this straight-grained hardwood. I group some closer together to indicate the color variation. I use a 2H to add very light tone with long, vertical strokes, adding a smooth quality.

Other Food Elements

I thought it would be a fun challenge to try to capture the coloration markings, form, and textures of these two very different food specimens.

Squash

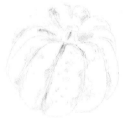

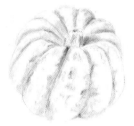

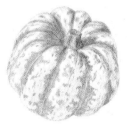

Step 1 I start off with an outline of the pitted surface of the squash and its color markings. I use carbon dust to put in the initial tones of the darker markings.

Step 2 Using carbon dust on the point of my stump, I add some dark tone to show the heavy creases and the shadow of the stem. I put some irregular tone in the lighter areas. I use a 4B for the stem.

Step 3 I use a 4B and circular strokes to deepen the dark areas, showing the ragged surface of the skin. I go over the light areas with a 2B, then lift out highlights and the lines along the creases.

Cheese

Step 1 I outline the cheese and use the side of the pencil to shade the creamy top of the cheese with light pressure and loose, oval strokes. I use vertical strokes to shade the side, and I darken the veins and the shadows.

Step 2 I use horizontal strokes that follow the form for the rind. Then I deepen the tones of the holes and jagged veins and create the slight cast shadow under the cheese to help keep it "grounded."

Step 3 With heavy pressure and a dull point, I deepen the holes, remembering to keep the variations in tone to show various depths. I crosshatch the cast shadow and deepen the lines around the cheese to show the heavy rind.

WINE AND CHEESE

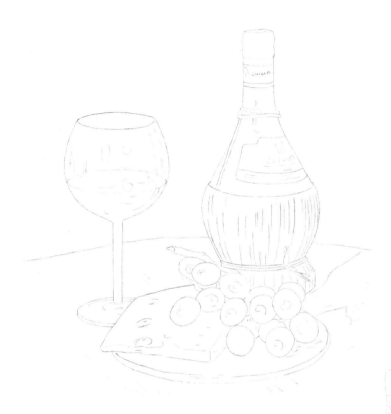

Step 1 I chose these objects for their range of textures. This composition contrasts the very hard, smooth glass with the rough straw of the bottle cover, while the grapes, cheese, and wooden tray offer intermediate textures. It's very important to pay careful attention to the reflections on the glass objects. I carefully sketch the scene on smooth plate-finish Bristol with a very sharp HB pencil. I look at the ovals of the glass and bottle to make sure they are accurate. I then clean up my drawing and am ready to start the shading process.

Step 2 For smooth subjects like glass, I start by applying carbon dust with a stump. I use oval-shaped strokes to mimic the hard surface of the glass and then use the remaining dust on the stump to indicate the dark reflections in the glass. I do the same for the wine, which takes on the sleek surface quality of the glass. For the straw wrapping on the bottle, I follow the bottle's form with long, vertical strokes, which are broken and uneven to show the natural fiber. I apply carbon dust to the grapes with quick strokes, which creates random variations. For the cheese, I use the stump to create long strokes that follow the flat shape of the cheese's form.

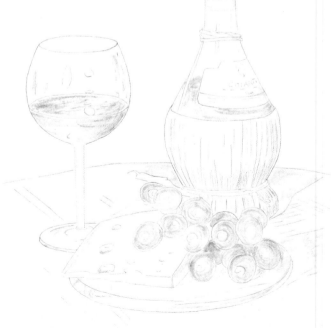

Step 3 Building up the glassy surface of the wine, I use a 2B pencil to create long, curved strokes; then I blend with my stump. I use vertical strokes for the rigid stem of the glass where there are reflections, and I use curved strokes where there are some darker tones at the base of the glass. I add light shading on the labels of the bottle. For the straw, I blend the first layer of graphite and use the side of the 2B to establish the soft shadows created by the overlapping straw. I add some dark form shadows to the grapes and then blend my strokes to create the slick skin. I add more tone to the cheese with my stump, and then I darken the depression in the cheese with my pencil. I add tone to the cast shadows on the table and then blend the strokes.

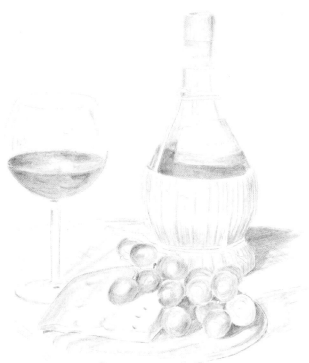

Step 4 Following the contours of the forms, I use a 2H pencil to add some shading to the glass, stem, and base to give them sharp, crisp edges. Returning to the bottle, I darken the wine using my 2B. At the back of the bottle where the reflections are, I blend even further, adding to the smoothness of the surface. I also add to the reflections in the glass by using the stump. I deepen the grapes and use a sharp HB to redefine the grapes' distinct edges. I use the side of the pencil for the thin stems of the grapes. For the creamy cheese, I shade using light strokes with my HB, following the direction of the form, and then I darken the wax rind with a 4B. I refine the delicate wood grain with an HB and draw in some details on the bottle labels.

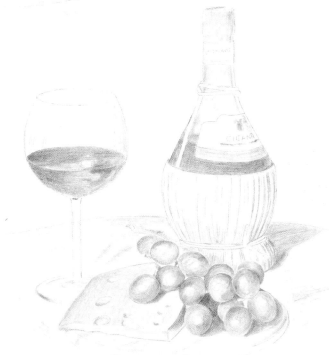

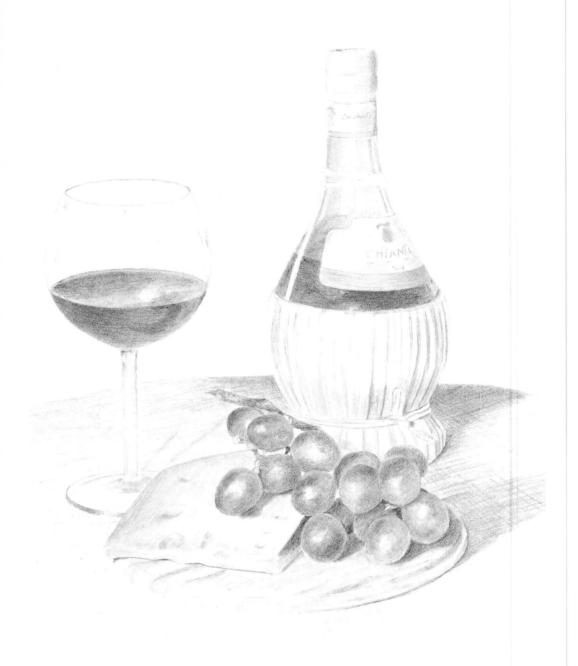

Step 5 I further deepen the tone of the wine in both the glass and bottle, using the dull point of a 4B. I use an eraser to heighten the smooth quality by lightly lifting out some reflections in the wine. I use an HB to shade the glass and form the reflections. For the bottle, I blend the tone; then I lift out the long highlight along the neck with a stroke that mimics the hard edge of the glass bottle. I use a 4B and tiny, circular strokes to darken the grapes, and then I lift out to further show the glossy skin by defining the highlights. I blend and lift out to create a smoother texture for the cheese, and I use a very sharp point to draw in the thin cast shadow echoing the rough edge at the bottom of the cheese. I create more detail in the lightly grained wooden tray using long strokes with a sharp pencil; then I add more texture to the tablecloth using crosshatching (see page 9).

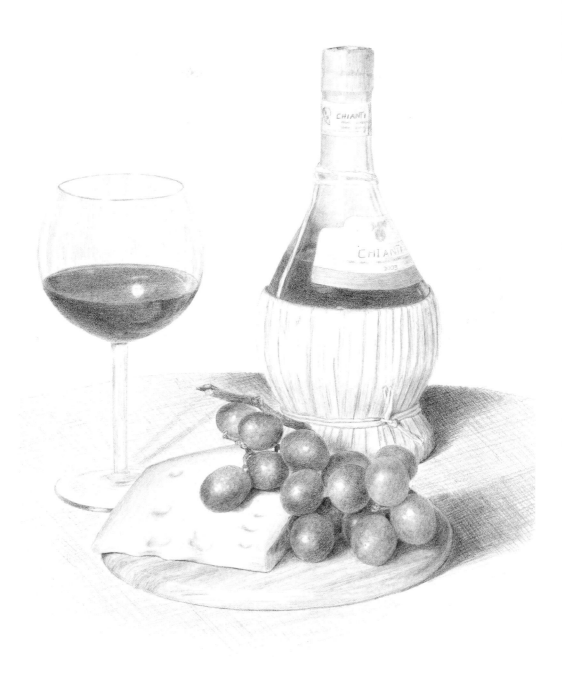

Step 6 I make the glass a little darker with a 2H to create more contrast for the reflections, and then I lift out some light areas to further emphasize the hard surface. For the base of the stem, I apply some crosshatching to indicate the transparency of the glass. I add a few small, vertical shadows to the upper label to create the irregular folds, and I sketch a bit more print on the labels without drawing every letter. Using my HB, I add more shading to the straw. I create the shadows cast by the grapes with the side of the pencil. I shade the jagged, depressed areas of the straw with long, curved lines, and I use a sharp point to draw a few splits in the straw. I redefine the grapes with an HB where needed. I also carefully place highlights on the cheese by lifting out—this helps define the depressions in the cheese. I use the point of an HB to draw more wood grain and add more crosshatching to the tablecloth.

FLORAL STILL LIFE TEXTURES

Flowers come in so many interesting forms, colors, and textures—it's no wonder they are an endless inspiration for artists! When setting up a floral still life, keep your containers and arrangements simple, with a textural quality that won't overwhelm the flowers.

Glass

Opaque Gloss Vase I apply carbon dust, and then I lift out the bright highlights. For the subtle highlights, I drag my eraser lightly across the tone of the vase.

Opaque Matte Vase This vase hardly has any highlights. I use an HB and make crisp edges to show the hard, smooth surface.

Clear Vase This vase is transparent, so the back of the vase can be seen from the front. There also are sharp highlights and reflections. I use a 2H for shading.

Ceramic

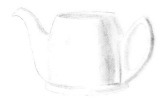
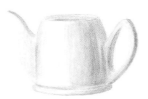
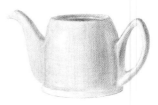

Step 1 Glazed ceramic clay is very hard and reflective. I create a "wash" with carbon dust and a stump, then establish the shadow patterns. My vertical strokes follow the form of the teapot.

Step 2 I go back with a sharp HB and draw light, vertical strokes that follow the contour of the teapot. Then I use strokes that reach across the teapot horizontally, particularly around the base.

Step 3 I build up the values of the teapot with vertical and horizontal strokes, and then I use the stump to blend. For crisp contrasts, I use an eraser to lift out highlights and spots of reflected light.

Fabrics

▶ **Fringe** I use a sharp HB to draw a detailed outline of the fringe and knots. The strands should be slightly frayed, reflecting the softness of the thread.

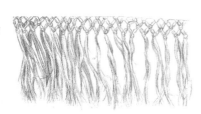

▶ **Crochet** Lace and crocheted fabrics have holes that add a lovely textural element. The holes create heavy shadow, but the fabric is still light and delicate.

PITCHER OF LILIES

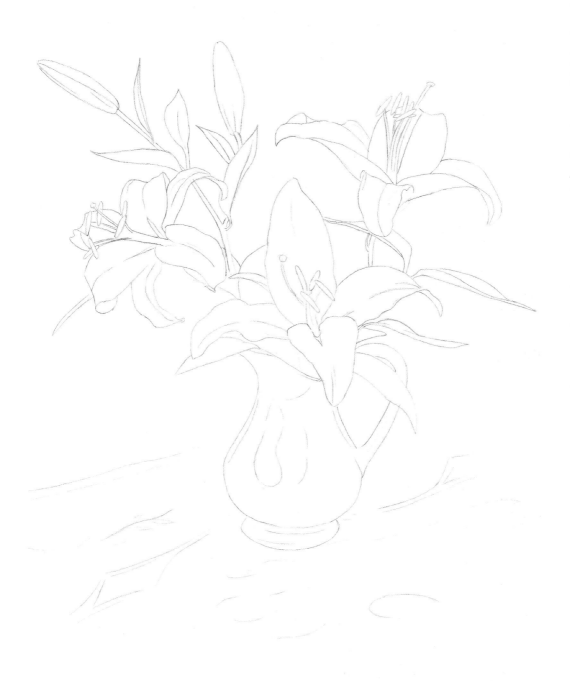

Step 1 I love the graceful, draping form of delicate tiger lilies and the interesting markings on their petals. For this composition, I contrasted the flowers with a heavy brass pitcher that I purchased in Italy, for an added benefit of including a pleasant memory in my drawing. First I draw an accurate outline with a sharp HB pencil on plate-finish Bristol paper.

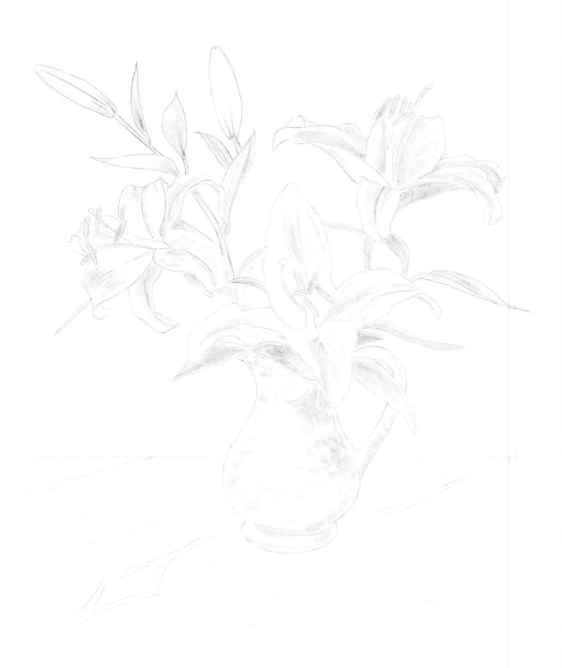

Step 2 I use carbon dust on a stump to apply the first layer of shading, so no pencil strokes are visible. I establish some tone in the flower stems, and then I apply carbon dust to the leaves, making my strokes follow the direction of the leaves. I work freely, adding a little more tone where the leaves are darker and lifting out some light tone in the petals of the flowers where they are pink. I use long, curving strokes following the form and folds of the petal. I keep the tones light and remember to retain the white borders of the flowers. I use the tip of the stump to give a very soft texture to the small, oval shape of the pollen-covered anther. Then I use a large stump and circular strokes to shade the brass pitcher. The texture is fairly consistent at this point.

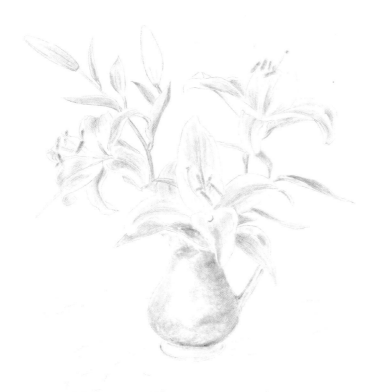

Step 3 I use a 2B pencil to add more tone to the stems, using long strokes along the length of the stems to show their strength and smooth lines. I do the same with the leaves. Then I carefully start adding tone to the petals. The color value is usually darker in the center and at the base of the petal, so I use a little more pressure in these places. I use a 6B to add a bit more texture to the anthers and the stigma. I shade the style with a 2B and use a curved, dark stroke at the base of the flower where the pistil and stamen emerge. There are two buds that have not yet opened, so I add just a little shading where their soft petals join the stem. I deepen the values of the pitcher using circular strokes, and then I blend the strokes. I place darker tone at the base of the pitcher and along the handle.

Step 4 I return to the stems and leaves to fully establish their even textures and the value of their green color, which is much darker than the value of the pink petals. I use a 2B, again using long strokes, to deepen the shadowed side of the stem by going over it with the point of a small stump. I shade the leaves, and I use a 4B in the darkest areas, such as at the base of the arrangement. While I am working on the leaves, I begin to alter- nate between a pencil and a blending stump. I allow some strokes to be more obvious to capture the appearance of the veining in the leaves. I also darken the undersides of some of the petals, keeping the strokes very soft looking. I take my 6B pencil and use the side of it to shade the pitcher irregularly. Then I lift out to maintain the highlight. I add some tone to the table where the cast shadow falls and then wipe it with a chamois cloth to smooth it.

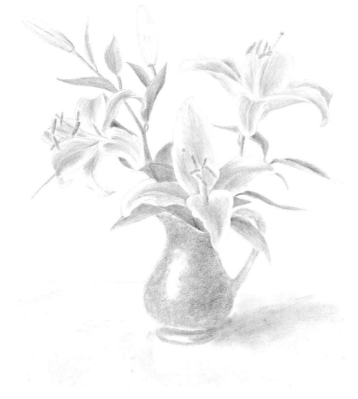

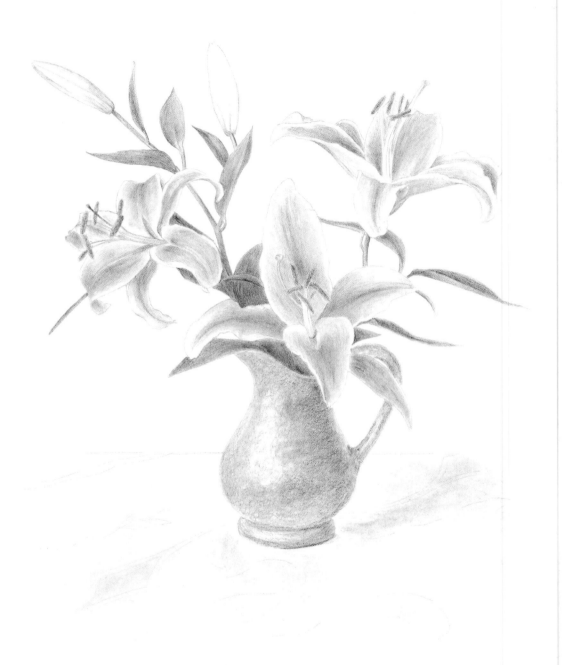

Step 5 At this point, my values and forms are well established, so I focus on refining the shading to show more texture. I use a pencil, a stump, and an eraser to create even tones and delicate transitions between strokes. I use the point of my pencil for small cast and form shadows, such as where the buds and the base of the leaf attach to the stem. I delicately shade the tight, smooth buds using an HB and long, light strokes. I smooth the tone on the velvety, soft petals and then touch up the edges, further defining the petals. I use a 4B with tiny, circular strokes to shade the anthers, adding to their pollen-laden roughness. I add more tone to the pitcher with a 6B, keeping it darkest on the side that is farthest away from the light and leaving the strokes rough to show the metallic texture. I lightly lift some tone from the edge of the right side of the pitcher to indicate the reflected light.

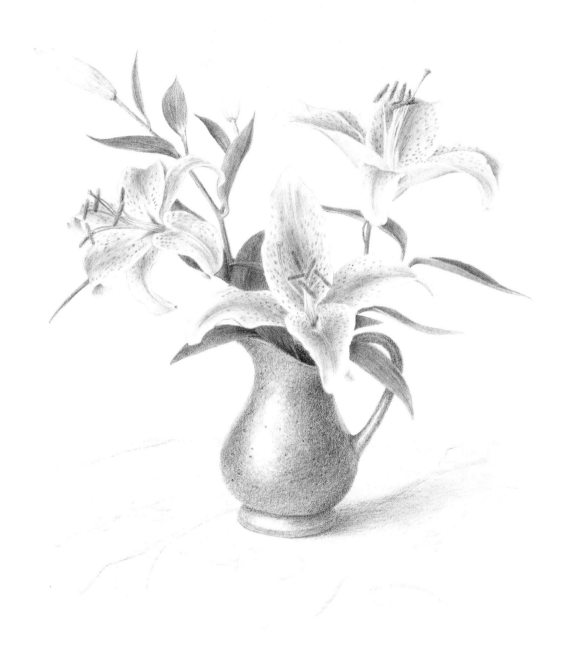

Step 6 I again darken the leaves with smooth, steady strokes, and then I use my kneaded eraser to lift out some thin venation lines. For the petals, I further refine the tonal shading using an HB, a stump, and an eraser. I lift out the white borders of the petals, and I add the flat spots that are so characteristic of the lilies. I also define the stamens and the pistils, strengthening the tone at the base of the flower where they merge. I smooth out the tones of the pitcher using a 4B with small, circular strokes, and then use the point of the pencil to better define the edges of the hard metal where there is a thin line of shadow at the base. I stipple in some dots with a 6B and randomly dab with the tip of the eraser to create the feel of the pitting. I add very light tone on the table using horizontal strokes with the side of the pencil. I use just a little pressure to deepen the embroidery pattern of the tablecloth. I also darken the shadow cast by the arrangement.

WILDLIFE TEXTURES

Nature provides some of the most exquisite and interesting textures. Drawing wildlife is especially helpful because each animal comprises a number of different textural elements. Think about a bird with its sleek feathers, scaly feet, smooth beak, and glistening eyes. What more could an artist ask for?

In my backyard, there is a wealth of textures just waiting to challenge me, from a delicate butterfly to a scruffy groundhog. All of the textures on this page can be found right outside my door. What is waiting outside your door?

Feathers

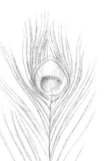
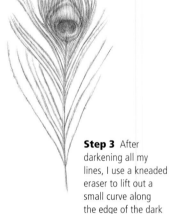

Step 1 To capture the wispy, fragile texture of a peacock's feather, I start by drawing thin lines that stem from a vertical centerline. Then I draw a circle within an oval for the "eye"— I draw the curved lines that surround the "eye" so that they follow the ovular form.

Step 2 I darken the center of the "eye" to emphasize the peacock feather's distinctive pattern. I keep the area around the center very light to indicate the change in color and the delicate feather texture.

Step 3 After darkening all my lines, I use a kneaded eraser to lift out a small curve along the edge of the dark center. (See "Lifting Out" below for more information.)

Lifting Out for Feathers

Here I use an eraser to lift out the white edges of the feathers. I go back in and reinforce the edges with pencil to show the defined edges of the feathers. It often is difficult to control the shape of the edges of the lifted area, so the delicacy of the edges can be lost. I use short lines that follow the direction of the feathers to create additional texture. Then I blend the background with an eraser to help make the feathers stand out.

Scales and Skin

Alligator I use a soft, broad pencil with plate-finish paper, as I don't want the effects of rough paper to interfere with the leathery, bumpy texture of the alligator's skin. Pay attention to the direction of the light source when dealing with textures—alligator skin is made up of many small ridges, and each ridge must be lit properly for the drawing to appear realistic.

Fish First I outline the scales, paying careful attention to the details. Then I add shading at the base of the scales where they overlap to show the distinctive flaky texture. Note that every scale has been given a highlight—this helps capture the fish's shimmery nature.

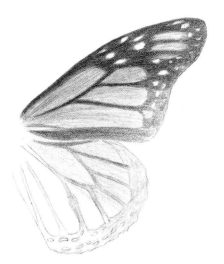

Butterfly First I carefully outline the drawing with a sharp HB pencil. I lightly draw the very thin veins, using long strokes. I go back in and put down another layer of tone, this time also covering the lighter areas of the wing. Next I use a 2B pencil to deepen the veins, gradually increasing the pressure on my pencil and using long strokes that follow the shape of the wing. I switch back to the HB and use long strokes to deepen the light tones of the wing, allowing some strokes to be darker to create a slight variation in the soft tones within the lighter area.

Frog Frog skin is usually moist, so using the smudging technique (see page 10) seemed appropriate. I use darker tones to create the raised bumps and lift out some graphite to add highlights to the slimy surface to give a wet look to the entire skin.

BLUE JAY

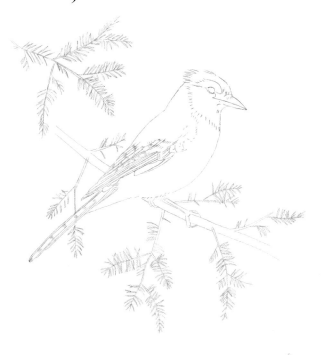

Step 1 I begin this drawing with a carefully detailed outline drawn with a sharp HB mechanical pencil. When drawing the head, I use short strokes to create the softer edges of the feathers. I refer to several photos to confirm that the feather patterns are accurate, and I indicate the black markings of the bird with some quick shading. Right now I am more concerned with capturing the basic features of the bird—details will come later.

Step 2 With a sharp 2H pencil, I darken the lines around the feathers to define them, and I add some dark markings using short strokes. At this stage I am still very concerned about the accuracy of the feather patterns, as markings on the wings and tail are very important in identifying a bird. As I draw, I make sure that all of my strokes follow the direction of the feathers—even at this early stage, texture is being created by my strokes. I shade under the wings, but I don't want the shadows to be too dark at this point. I darken the eye, remembering to leave the wet-looking highlight white. I remind myself that the eye is like a sphere and use tiny strokes that follow the form of the sphere. I switch to an HB so I can outline the rigid beak. I put some tone in the beak but leave it lighter on the upper part to show the light hitting it.

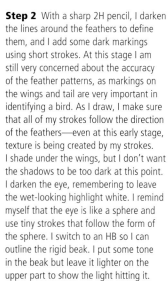

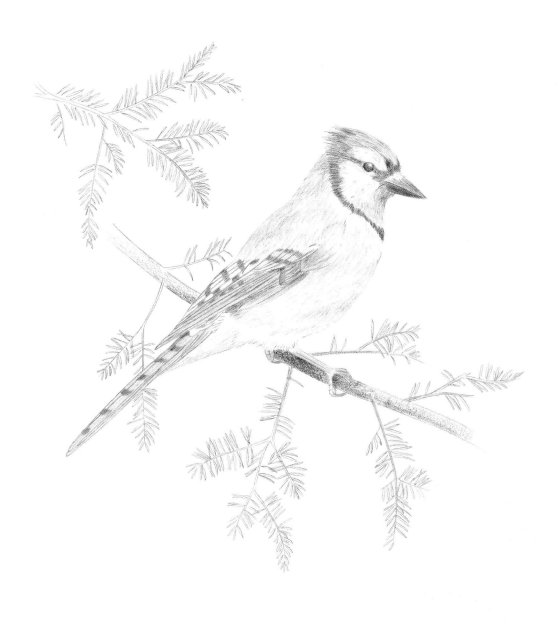

Step 3 I begin working on the shading that will contribute to the sense of the bird's form but remember to maintain the softness of the feathered body. At this stage, I work back and forth between an HB and a 2B pencil. I begin developing values, concentrating on the bird's body and head, which are both egg shapes. Using short, uneven pencil strokes, I start putting some tone on the back, the belly, and the back of the head. I also apply some darker tone to the crown of the head to indicate the blue color. I darken the beak, but I'm careful to keep some highlights to emphasize its smooth texture. At the base of the beak, I draw little lines to indicate short feathers. On the wings, I use long strokes to shade, making sure to keep the white markings evident. I use a broad-point 6B pencil to shade the branch with circular strokes. I lighten the shading as it recedes into space.

Step 4 It's important to balance the values of the form with the values of the color while keeping the textural elements intact. The form values are the values created by the light hitting the blue jay, whereas the color values are the ones representing the different colors of the actual bird. The texture emerges from the way these values are applied. In pencil, white is expressed as light shading, blue is the midtone, and black is the darkest shading. If I run into a conflict between the form and color values, I give priority to the form values. Now I deepen the black markings with short strokes of a sharp HB, leaving the white markings free of any tone. Where the feathers overlap and at the base of the tail and under the wings, I apply a deeper shade to indicate a shadow using the side of a 2B pencil. I add more shading to the head with short lines, and at the back of the crown I use longer lines for the sharply protruding feathers. Then I deepen the tone on the back and the belly. I leave a few little lines that extend beyond the edge of the bird, producing the feathered texture.

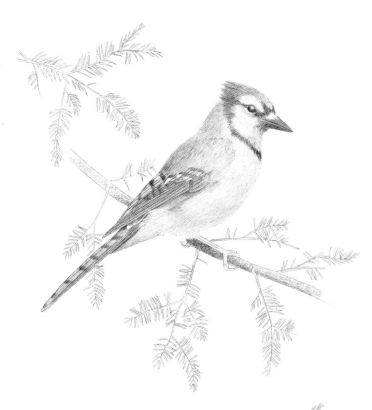

Step 5 I now begin to focus on creating smoother and more natural tonal transitions. I further develop the eye, deepening the black tone and sharpening the highlight. I darken the blue jay's beak, being careful to leave a slightly lighter tone just at the edge. I add some longer, deeper lines to the back of the crown to give depth to the parted feathers. I also add a few short, light strokes in the white area of the head. I keep these lines very light, so as to not lose the value of the white. I switch to a dull 4B to darken the feet with circular strokes, and I add a small shadow under them. The texture of the feet is very different from the texture of the feathers, so try to create more of a scaly feel. I now give more attention to defining the tones of the branch. I deepen the shading with heavier, irregular, circular strokes, using a broad 6B. I make the branch under the bird very dark to indicate the cast shadow. Then I put some light shading in the pine needles using a few long strokes and an HB.

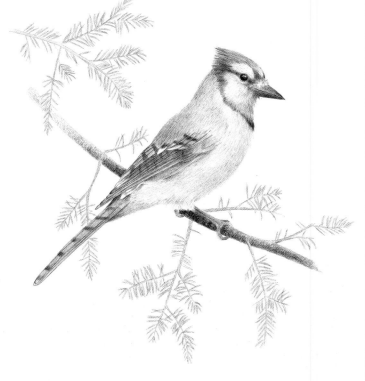

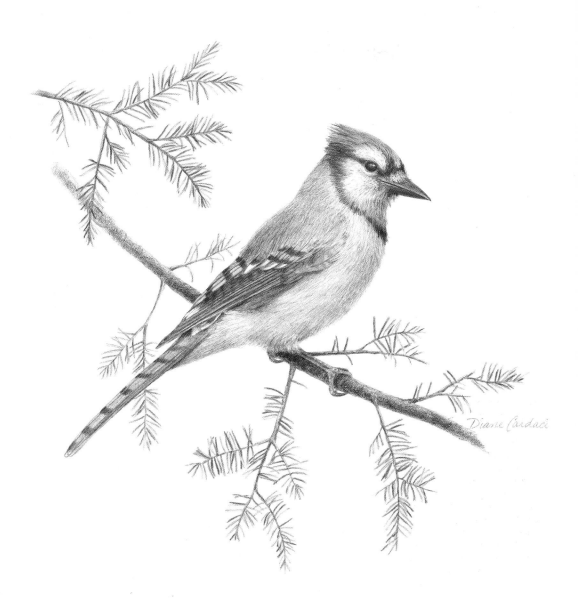

Diane Cardaci

Step 6 I deepen the wings even further with a 2B pencil to create more contrast. Then I darken the grays of the shadowed belly tones. I add a few more detailed textures to the feet with a 2B, using heavy pressure. I also add some short, sharp lines to indicate the smooth edges where the feathers overlap, and I add short, sharp lines for the small feathers at the upper base of the beak. I shade with a 4B to give form to the small branches, and I use a blunt 4B to add tone to some of the needles, giving them more depth and a prickly texture. I use a kneaded eraser to lift out just a touch of graphite, emphasizing the reflected light at the bottom of the main branch. Leaving some small feathers sticking out softens the blue jay but at the same time doesn't look unkempt. I clean up the drawing with my kneaded eraser and lift out any white markings I need to add to the feathers. I am very careful not to overwork the drawing. At this final stage, I look at my art in a mirror to see if there are any areas that I am not satisfied with, and I adjust my drawing accordingly.

LANDSCAPE TEXTURES

When there are a lot of trees, rocks, and other natural elements in a landscape, it can seem overwhelming to try to capture all of the textures. To simplify the process, I start by mapping out the major masses of the landscape elements, breaking them down into more manageable shapes. Then I can add other textural aspects, such as clouds and water, which bring the scene to life.

Land

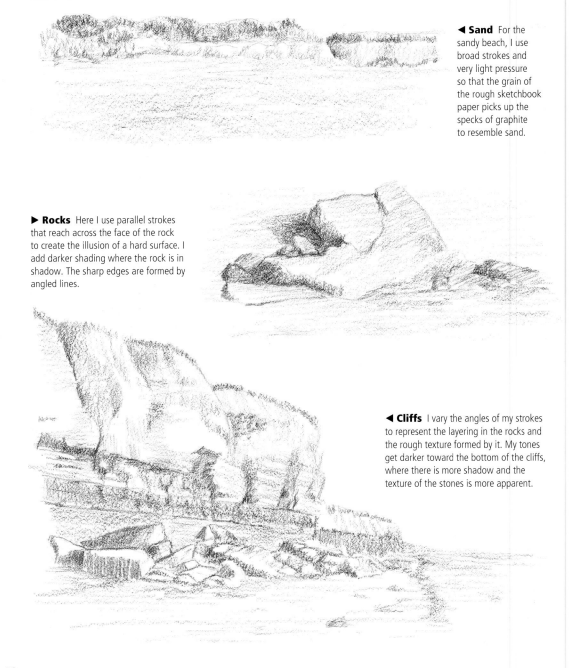

◀ **Sand** For the sandy beach, I use broad strokes and very light pressure so that the grain of the rough sketchbook paper picks up the specks of graphite to resemble sand.

▶ **Rocks** Here I use parallel strokes that reach across the face of the rock to create the illusion of a hard surface. I add darker shading where the rock is in shadow. The sharp edges are formed by angled lines.

◀ **Cliffs** I vary the angles of my strokes to represent the layering in the rocks and the rough texture formed by it. My tones get darker toward the bottom of the cliffs, where there is more shadow and the texture of the stones is more apparent.

Clouds

Cumulus For fluffy clouds, I dab my eraser gently for light gray areas and use more pressure to lift out the whites.

Cirrus To draw these wispy clouds, I lift out using a curving motion and then extend that motion horizontally.

Cumulonimbus To capture these dark storm clouds, I dab the graphite with my eraser; then I add dark tone and blend.

Water

Still Water When the air is perfectly still, water can appear almost like a mirror, reflecting objects clearly. To make the reflections evident, I use dense, dark strokes.

Rougher Water Here I deliberately allow the lines to be more wavy than in the previous example. I lift out with long, horizontal strokes. No reflections can be seen.

Waves Waves produce a sense of movement through frothy white caps. I start with the shape of the wave, create the darker parts of the water with a 4B, and blend.

I create a few white lines in the dark tone with my eraser, showing the building white caps. I dab the eraser to create the spray and lift out wavy shapes to make the foam.

Trees

Painterly Strokes I use a wide, soft lead to lay down large, dense areas of tone. Finishing with some shorter strokes, I stipple to create detail and add texture. This gives a tree an open, leafy pattern.

Linear Strokes I use a sharper pencil and small, thin strokes. I vary the direction and density of my lines to develop the dark and light values that establish the form of the tree. This technique is ideal for prickly pine trees.

Combining Techniques I put down some tone and then smear it with a blending stump. Then I use short, linear strokes with a sharp pencil to create the texture. This creates a tree with a softer-looking texture.

LAKE SCENE

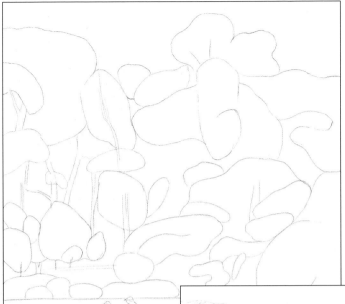

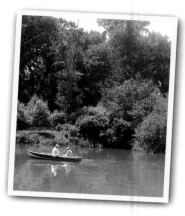

Taking Artistic License You have the freedom to change elements of your photo references. Here I changed the direction of the boat, which I thought would improve the composition.

Step 1 I like to think of a scene as a sort of jigsaw puzzle of light and dark shapes. I look for the major organic shapes and leave the smaller ones for a later stage. I draw in just a few major shapes, such as the trunks and branches of trees, to help me with this process. I do not include any details, and I indicate just a few lines for the water so I know where the darkest areas are. I'm not concerned with texture yet.

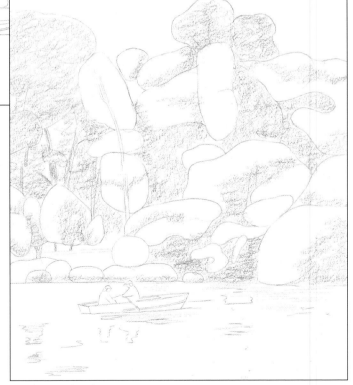

Step 2 Using the side of a 6B pencil, I lay in tone for the large masses of foliage. I do not worry too much about being exact. I use long strokes to put some tone on the trunks. Then I switch to the side of an HB and very lightly put down some preliminary tone in horizontal strokes to show the calm water.

Step 3 I continue the process of developing the masses, but now I use a thick blending stump, blending the textures that are indistinct in the background. I think of myself as painting more than drawing, creating a wash effect by loosely smearing the tones I have already put down for the foliage. I use circular strokes and keep them very free, not worrying about the outlines. I use long strokes with the stump on the main trunks and branches, and then I use a sharp HB to create the hard edges that better define their texture. For the water, I dip my stump into some carbon dust and apply it to the darker areas of the water, using long, free, horizontal strokes. I switch to a thin stump and apply a "wash" to the boat.

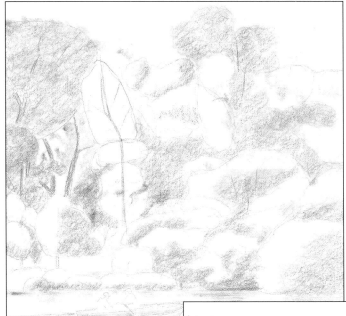

Creating Bark I use the side of a 2B to shade the bark of the trees, varying my lines so the patterns aren't rigid. Once the tone is built up, I go back and accentuate the grooves with the point of my pencil. Then I lift out with my eraser. The more range you create between the lightest and darkest tones, the rougher the bark will appear.

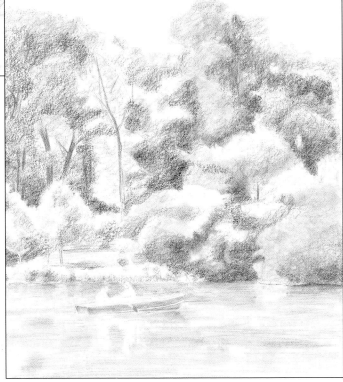

Step 4 Now I start defining the shapes and textures of the foliage masses. Using a 6B, I go back in with loose strokes and put more tone in the darker, smaller masses. I break down the light and dark areas and refine their shapes. For the water, I use the side of an HB, allowing my hand to create slight waves in the lines. I add another layer of carbon dust with my stump where the tonal variations occur in the water.

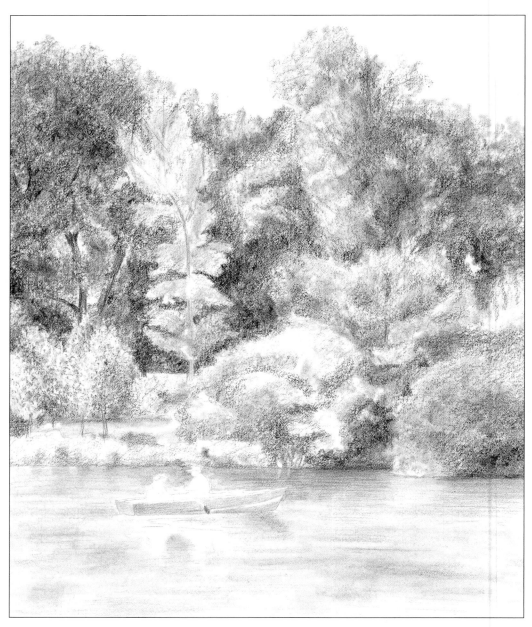

Step 5 At this point, I begin to work back and forth between my stump and 6B pencil, darkening and breaking up the foliage masses and defining differences in the textures they create. I continue to work very freely, allowing accidental effects to create more atmosphere. I use a sharp 2B to lightly put branches in the tree masses that are closest to the sky. With heavier pressure, I put some additional branches in the foliage masses. For the small trees near the water, I use a 6B to stipple, showing the leafy textures and creating more stippling where the form turns away from the light. I repeat the same process I used earlier for the water and darken the shadowy areas. I use the deepest tone along the bank, leaving some areas lighter based on the shape and textural quality of the reflections.

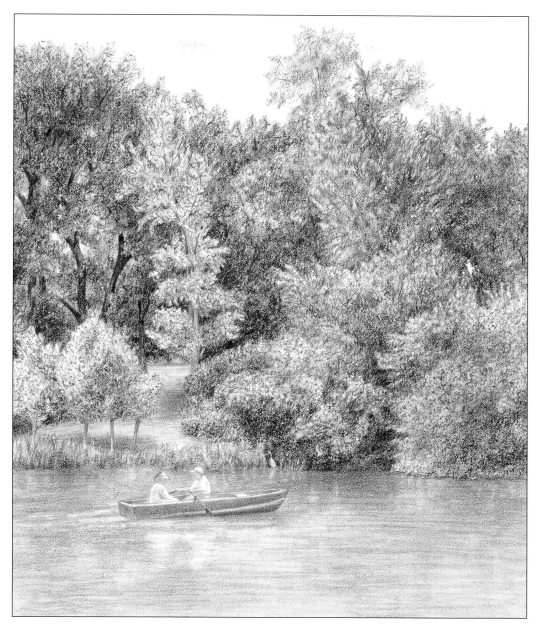

Step 6 Now the forms are well established, and the interaction of the paper with my loose strokes has created a good basis of texture. The sleek sides of the boat are shaded more heavily. Next I use more deliberate strokes to create different types of textures within the trees. I lightly stipple along the branches that extend into the sky to create an illusion of leaves; I use the 2B to put in a few more branches; and I draw some small, curved strokes with a 4B, adding individual texture to the trees. For the grassy area, I use the stump and add a few pencil strokes. I use my kneaded eraser to pick out additional lights in the foliage, boat, and water, helping emphasize the darks. I carefully define the shape of the bird by the shore and the trunks of the small trees with the sharp point of an HB. I don't want to create too much detail on the people, so I add just a little shading.

CITYSCAPE TEXTURES

I enjoy spending afternoons walking through a town with my camera and sketchbook, looking for uncommon textures in common places. I photograph or sketch the little details that will bring my drawings to life. Wooden doors can help add rustic texture to buildings, and stucco and brick can bring depth to otherwise flat walls. After all, cityscapes are a lot more than just buildings and people.

Bricks with Stucco

Step 1 First I outline the brick pattern, and then I loosely draw horizontal strokes within the bricks. I smear the tone with a stump, filling in each brick shape.

Step 2 I draw some wavy lines to signify the rough, broken edges of the stucco. Then I lightly go over the entire drawing with a 6B so the paper picks up tiny specks of graphite.

Step 3 Now I use a sharp HB to create very thin, slightly wavy lines where the old stucco is breaking away from the brick. Then I darken and refine the hard edges of the bricks.

Doors

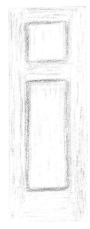 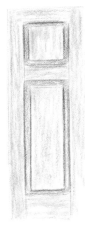 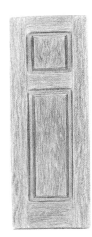

Step 1 I add tone to my outline with wavy, vertical strokes to indicate the grain of the wood. I use heavier pressure to make the wood darker where the panel is recessed.

Step 2 I add more shading and then gently smudge it with a stump to soften the look. Next I put dark tone in the recessed groove. I use a very sharp HB to accentuate the lines where the wood pieces join.

Step 3 Now I darken the tone of the wood and add lines to show the grain. Layers of tone add more natural variations to the texture of wood. I add a thin, dark strip at the bottom of the panel to help add depth.

Metals

Dull **Weathered** **Shiny**

Dull metals do not have distinctive borders to their highlights. Weathered metals feature little bumps that catch individual lights and shadows, breaking up the tone and highlights. Shiny metals have bright highlights with sharp edges.

Roofs

▲ Metal Roof Here is an example of how you can still create smooth-looking tone on rough paper. I use the point of an HB pencil to draw very light lines that are close together—this creates the illusion of continuous, unbroken tone.

▲ Shingles To capture the uniform, scalelike appearance of shingles, it's important to show how they overlap one another. I put heavier lines between a few of the shingles to depict this layering.

◄ Old Barrel Tile Don't worry about perfection when drawing this subject because the roof is usually worn and sunken in places. I add random areas of tone to indicate the color variations that you see in many old roofs in Italy.

Planters

Stone For this stone planter, I use short, vertical strokes to create a hard-edged foundation. The flat edges and square corners of the upper level look like a stone slab or concrete, but they still have a cold, hard texture. I add more of these strokes where the planter is in shadow.

Wood To depict this wooden barrel, I draw strokes that follow the grain of the wood—first I use the point of the pencil to create the individual pieces; then I use the side of the pencil in short strokes to indicate the roughness of the wood. For the metal bands, I shade using the side of the pencil in long strokes.

PLAZA SCENE

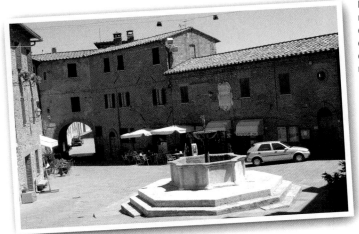

Making Adjustments Before I start my drawing, I have to check my reference photo. The camera lens distorts, especially when a wide angle like this one is used. I adjust the vertical lines in my drawing accordingly.

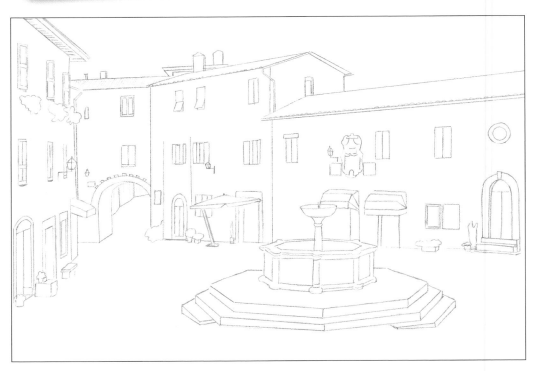

Step 1 This old Italian town is filled with textural detail, so it's important that I take some time to decide which details I want to emphasize and which I want to take out. For example, I decide to leave out the cars, the flowers on the ground, the wires above the buildings, and the tables and chairs underneath the umbrella. Then I begin to think about the paper I want to use to capture all of the textures. The old stone buildings, the shutters, and the stone fountain make it an easy decision to use rough paper. Now I'm ready to begin my sketch—I use a sharp HB to create a heavy outline that will show through my initial shading.

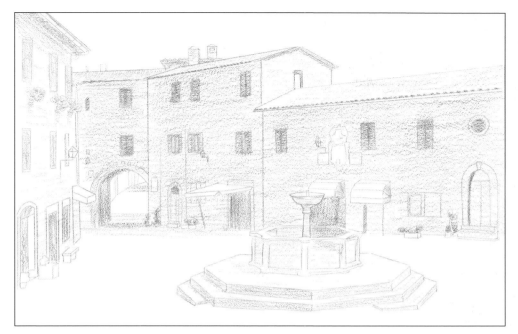

Step 2 I use broad strokes and the side of a 6B to lay tone across the buildings, and then I apply uneven strokes to the lengths of the roofs. The texture of the rough paper picks up the flecks of graphite, giving a sense of the old stone. I very lightly shade the smooth stone of the fountain, and I switch to a thinner lead to depict the slatted texture of the wooden shutters.

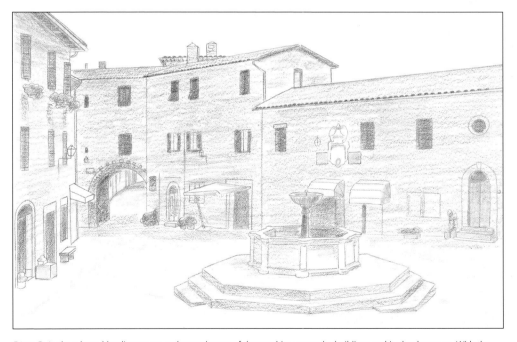

Step 3 I take a large blending stump and spread some of the graphite across the buildings and in the doorways. With the carbon dust left on my stump, I put tone on some of the smaller, more refined details, such as the little bench, the umbrella, and the awnings. I apply carbon dust on the dark metal fountain, using smooth strokes. Now I use my 6B to deepen all the tones on the building and roofs. I use uneven strokes, which add to the textural quality of the town.

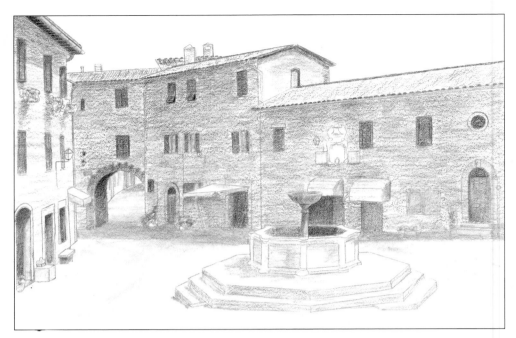

Step 4 This step is mainly a deepening of all the tones. I darken all the cast shadows and areas that aren't hit by the light source. I keep my strokes uneven across the buildings and roofs to reflect the rough textures of the old materials. I smudge across the building but not on the roof to maintain its highly granular texture. I add more darks to the metal and interior of the fountain with the carbon dust. I smear the shadow that runs across the back of the piazza.

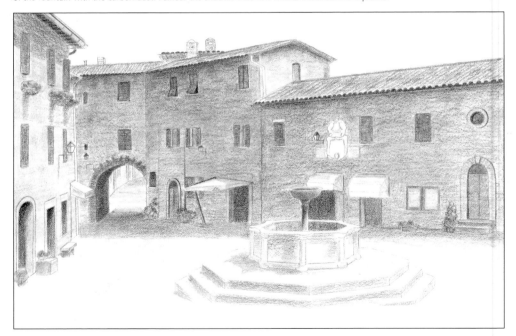

Step 5 Using a 4B, I add lines across the width of the roof to establish the bumpy texture of the tiles. I sharpen the edges of the windows and doorways, using my eraser when necessary to correct lines. I use a 2B to refine more details, such as the lanterns on the buildings, the crest, and the umbrella. I also refine the rough stones around the large archway. I add more tone to the main building and use my stump to smear it. Then I smear the tone of the lighter building on the left.

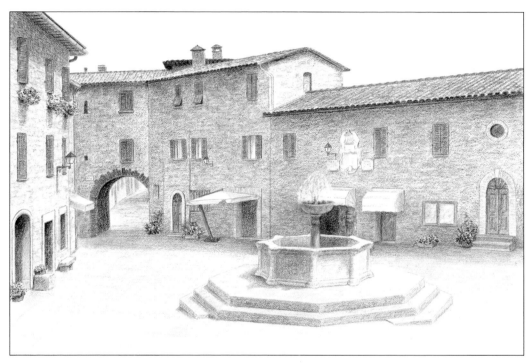

Step 6 I further develop the tones of the fountain, alternating between the 4B and the stump. I want to maintain the light of the sun reflecting off the old marble, so I don't apply too much tone. I also don't worry about making perfect lines because the fountain is weathered and chipped with age. I use a 2B to refine the smooth, dark metal part of the fountain and lift out highlights with a kneaded eraser. I also use the eraser on the building here and there to add more textural relief. I add uneven, curved strokes to the roof to give a sense of the barrel tiles without drawing them individually. I add some lines across the shutters to create the imperfect texture of the slats, and then I sharpen the edges and architectural details. I use stippling to create the texture of the plants, leaving some white spots to indicate flowers. I use short, heavy strokes to further define the sharp stone texture around the archway. As a final touch, I "turn on" the water in the fountain by lifting out dabs and streaks with my eraser to create the soft spray.

ANIMAL TEXTURES

Once you've mastered the subtleties of rendering fur and hair textures, you'll be able to draw a whole zoo full of animals! Animals are more than their coats, however; for example, a dog has a wide array of textures to experiment with, from the shining eyes to the wet nose.

Fur and Hair

▲ **Curly** I create a base tone using carbon dust and a stump. Then I lift out long, curly, white lines to achieve the kinky texture of the hair. I add curly lines on top of the white areas with a very sharp HB pencil.

▲ **Silky** I outline the prominent hair patterns with an HB and then put in some tone with strokes that follow the gentle waves of the hair. Then I use an eraser to pick out shiny highlights.

▲ **Short and Wiry** I put down some carbon dust and blend with a stump, using short strokes when blending. I draw short lines to develop the hair growth patterns and make slight changes to the direction of individual hairs to produce the wiry texture.

▲ **Short and Smooth** I lay in tone using carbon dust. Then I make several very short strokes with the side of a 2B pencil to achieve the smooth-textured appearance.

▲ **Long and Fluffy** I put down my base tone, then add some long, slightly curved, light strokes with the side of a 2B. On top of that, I put in thin lines with the point of the pencil and add some heavier lines where the hair is darker.

▲ **Long and Smooth** I draw long, wavy lines, then add tone with carbon dust. I alternate shading with the side of the pencil, drawing fine lines with the point of an HB, and lifting out white areas with an eraser to get the soft look.

YORKSHIRE TERRIER

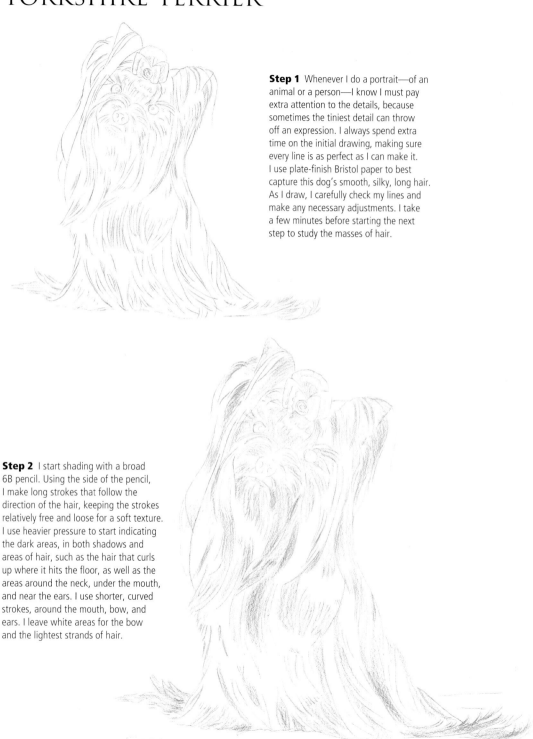

Step 1 Whenever I do a portrait—of an animal or a person—I know I must pay extra attention to the details, because sometimes the tiniest detail can throw off an expression. I always spend extra time on the initial drawing, making sure every line is as perfect as I can make it. I use plate-finish Bristol paper to best capture this dog's smooth, silky, long hair. As I draw, I carefully check my lines and make any necessary adjustments. I take a few minutes before starting the next step to study the masses of hair.

Step 2 I start shading with a broad 6B pencil. Using the side of the pencil, I make long strokes that follow the direction of the hair, keeping the strokes relatively free and loose for a soft texture. I use heavier pressure to start indicating the dark areas, in both shadows and areas of hair, such as the hair that curls up where it hits the floor, as well as the areas around the neck, under the mouth, and near the ears. I use shorter, curved strokes, around the mouth, bow, and ears. I leave white areas for the bow and the lightest strands of hair.

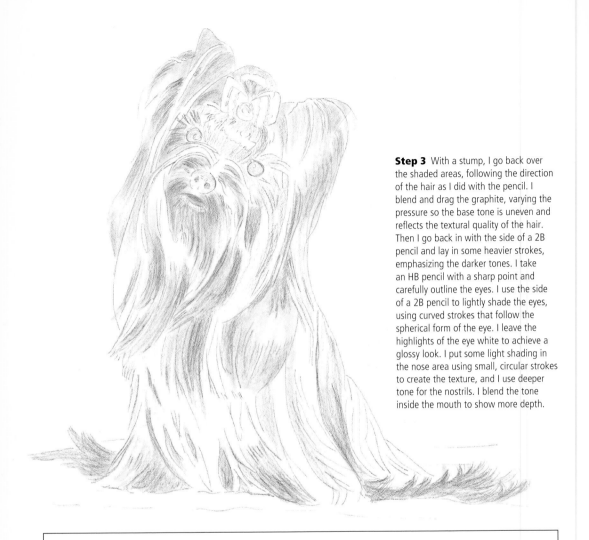

Step 3 With a stump, I go back over the shaded areas, following the direction of the hair as I did with the pencil. I blend and drag the graphite, varying the pressure so the base tone is uneven and reflects the textural quality of the hair. Then I go back in with the side of a 2B pencil and lay in some heavier strokes, emphasizing the darker tones. I take an HB pencil with a sharp point and carefully outline the eyes. I use the side of a 2B pencil to lightly shade the eyes, using curved strokes that follow the spherical form of the eye. I leave the highlights of the eye white to achieve a glossy look. I put some light shading in the nose area using small, circular strokes to create the texture, and I use deeper tone for the nostrils. I blend the tone inside the mouth to show more depth.

Canine Eyes

Eyes are the windows to the soul. It's important to draw them with plenty of expression. A dog's eye is different than a human's, so pay close attention to the tones you use.

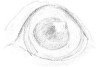

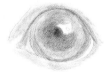

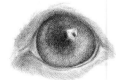

Step 1 I outline the eye; then I use circular strokes to create a base tone. I put darker shading in the center of the iris for the pupil, as well as around the outer edge. I leave the square-shaped highlight white.

Step 2 Next I deepen the tone in the pupil, around the outside of the iris, and along the eyelids. The contrast of the dark pupil against the white highlight makes the highlight appear even brighter.

Step 3 I maintain a sharp edge for the highlight, which gives the eye a wet, glossy look. I shade around the eyes using short strokes with the side of the pencil; then I draw a few hairs around the eye with a sharp point.

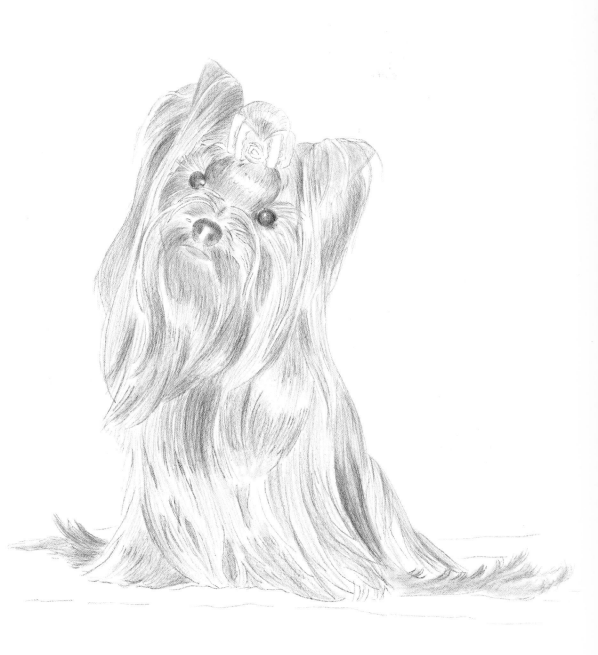

Step 4 At this point, I am ready to define the texture of the silky hair patterns. Using a sharp 2B, I draw long strokes, curving them where the hair is wavy. Where the hair gathers at the bow, I use short, curved strokes. I do the same for the shorter hairs around the face. I put in some darker tone where the head casts a shadow. I also darken the hair along the left side of the face; this helps define the softness of the long, lighter hairs draped over the ear. Next, with the side of an HB, I add deep shading around the edge of the eyes. For the nose, I continue to use circular strokes to deepen the value while maintaining the distinct texture. Then I use my eraser to lift out some highlights in the hair.

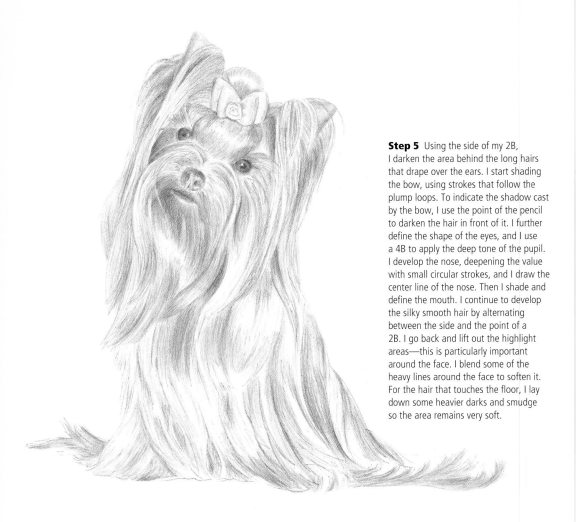

Step 5 Using the side of my 2B, I darken the area behind the long hairs that drape over the ears. I start shading the bow, using strokes that follow the plump loops. To indicate the shadow cast by the bow, I use the point of the pencil to darken the hair in front of it. I further define the shape of the eyes, and I use a 4B to apply the deep tone of the pupil. I develop the nose, deepening the value with small circular strokes, and I draw the center line of the nose. Then I shade and define the mouth. I continue to develop the silky smooth hair by alternating between the side and the point of a 2B. I go back and lift out the highlight areas—this is particularly important around the face. I blend some of the heavy lines around the face to soften it. For the hair that touches the floor, I lay down some heavier darks and smudge so the area remains very soft.

Canine Noses

A dog's nose is wet and leathery—it's an interesting combination of rough and shiny textures.

 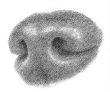

Step 1 First I draw an outline of the nose with the highlights clearly de-lineated. I use circular strokes with a 4B to create the base tone. Then I put darker tone in the nostrils.

Step 2 I add another layer of tone, still using circular strokes to build the leathery texture. I leave white spots for the highlights on the top of the nose and around the edges of the nostrils.

Step 3 I make the deep part of the nostrils as dark as possible. I break up the highlights with a few strokes, but I make sure to keep them white and visible because the highlights create the illusion of wetness.

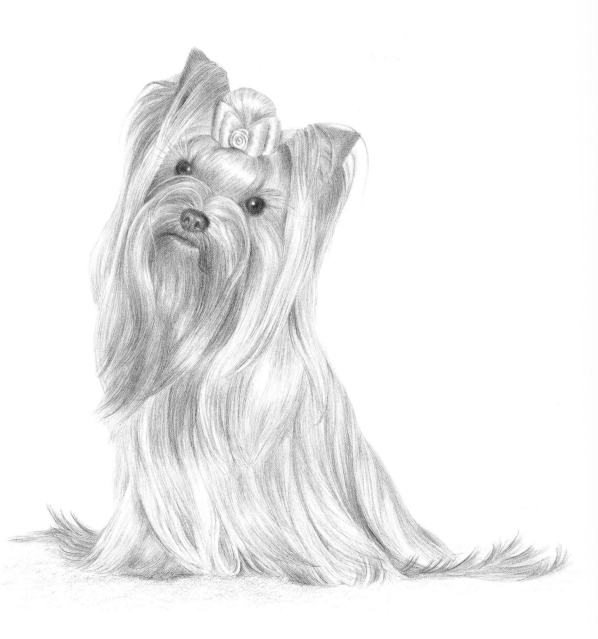

Step 6 Now I am at the stage where I bring everything into sharp focus. I deepen the tone of the ears using short strokes, delicately shade the soft bow and deepen its shadows, darken the eyes and create a crisp highlight with an HB pencil, and deepen the tone of the nose with more circular strokes. I am careful to leave the highlights on the nose because they give it a wet quality. Next I use a sharp point to put in the shorter, dark hairs below the mouth. Then I develop the strands of hair that stand out around the face. To do this, I alternate between lifting out the light areas and softly shading the darker areas. Now I add some sharp, fine lines around the face. I work on the body hair, lifting out more highlights to add a silky shine. I use circular strokes with a broad 6B to create a soft, carpetlike texture for the floor.

PORTRAIT TEXTURES

Capturing a likeness can be one of the greatest challenges for an artist, yet it also can be incredibly rewarding. Careful observation, coupled with a thorough understanding of the form of the head, is the foundation of a successful portrait. Consideration must be given to how the light flows over the head and facial features, as well as the very different textures of hair, teeth, skin, and eyes.

Hair

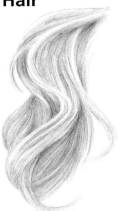

◄ Light and Wavy
Carbon dust and a stump create a base of light, subtle tone. I add long, flowing lines, following the soft waves of the hair. The strands in the foreground stay very light to emphasize the color of the hair.

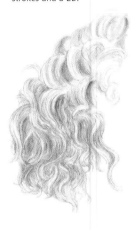

◄ Dark and Straight
First I outline the sculptured shape of this hairstyle and then apply a layer of carbon dust. Because the hair is so sleek, there is a strong band of highlights. I apply even tone with long, curved strokes and a 2B.

► Dark and Wavy I draw the main, curving hair forms; layer in some carbon dust; and draw wavy lines with the point of a 2B pencil. I use a 4B for the darkest darks and lift out the lighter, highlighted strands with a kneaded eraser.

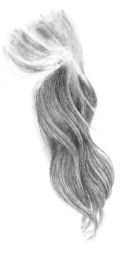

► Light and Curly
I outline the main masses of curls and some individual hairs. Then I use a sharp HB to shade. I lay in some carbon dust for the hair that is in shadow. Then I lift out some highlights with curved strokes.

Fabrics

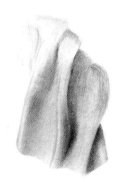

▼ Woven These highlights aren't sharp, but the tone is lighter where the light hits. I use crosshatching to shade, achieving a heavily woven texture.

▼ Lacework This fabric is matte, so the tonal transitions are very soft with no bright highlights. I make the dark holes with a sharp 2B.

▲ Flannel I apply carbon dust using circular strokes. Then I layer in long strokes with a 2B and blend, keeping the highlights soft and subtle.

▲ Satin I draw the main folds, then apply a layer of carbon dust. I define the highlights with my eraser for shine, and I lift out for the stitches.

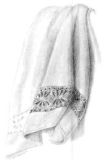

A YOUNG GIRL

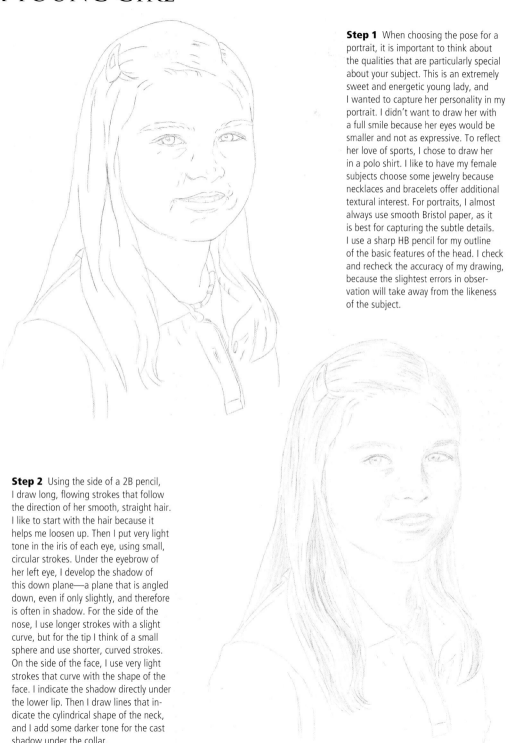

Step 1 When choosing the pose for a portrait, it is important to think about the qualities that are particularly special about your subject. This is an extremely sweet and energetic young lady, and I wanted to capture her personality in my portrait. I didn't want to draw her with a full smile because her eyes would be smaller and not as expressive. To reflect her love of sports, I chose to draw her in a polo shirt. I like to have my female subjects choose some jewelry because necklaces and bracelets offer additional textural interest. For portraits, I almost always use smooth Bristol paper, as it is best for capturing the subtle details. I use a sharp HB pencil for my outline of the basic features of the head. I check and recheck the accuracy of my drawing, because the slightest errors in observation will take away from the likeness of the subject.

Step 2 Using the side of a 2B pencil, I draw long, flowing strokes that follow the direction of her smooth, straight hair. I like to start with the hair because it helps me loosen up. Then I put very light tone in the iris of each eye, using small, circular strokes. Under the eyebrow of her left eye, I develop the shadow of this down plane—a plane that is angled down, even if only slightly, and therefore is often in shadow. For the side of the nose, I use longer strokes with a slight curve, but for the tip I think of a small sphere and use shorter, curved strokes. On the side of the face, I use very light strokes that curve with the shape of the face. I indicate the shadow directly under the lower lip. Then I draw lines that indicate the cylindrical shape of the neck, and I add some darker tone for the cast shadow under the collar.

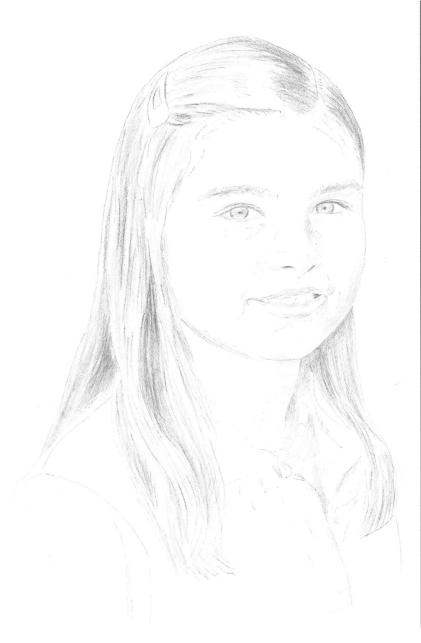

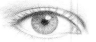

Step 3 I begin to blend the hair with a large stump. Then I go back and lay in more tone with a 4B for definition around the area where the hair parts and around the side of the face. With the lightest touch, I slightly blend the pencil strokes around the side of the face, being careful to follow the softly rounded contour of the cheeks. With a smaller stump, I lightly blend the areas around the eyes, mouth, nose, and eyebrows. I take my 2B pencil and put some deeper tone in the nostrils, the corner of the mouth, and the pupil of the eye. I darken the lines around the eye, making the line above the eye thicker to indicate the lashes. I work in light layers because it allows me to slowly develop the form. I study the subject as I draw, so by the time I start using deeper tones that would be more difficult to erase, I have a much greater understanding of the forms and shadows.

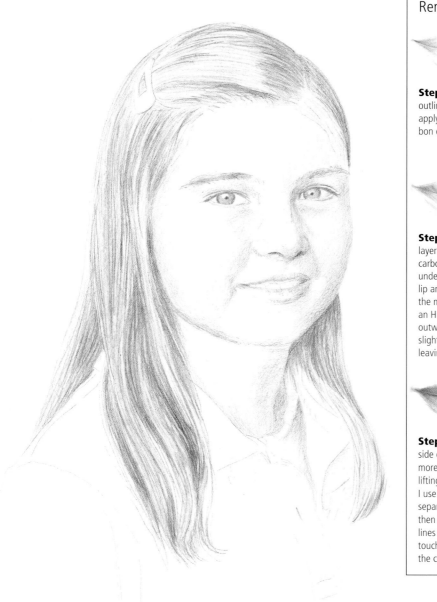

Step 1 I start with an outline of the mouth and apply light tone with carbon dust and a stump.

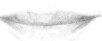

Step 2 I add another layer of tone with the carbon dust and darken underneath the bottom lip and in the corners of the mouth. I switch to an HB pencil and stroke outward with short, slightly curved lines, leaving white highlights.

Step 3 Now I use the side of the pencil to add more tone to the lips, lifting out the highlights. I use a 2B to draw the separation of the lips; then I add more contour lines with an HB. I add a touch of carbon dust to the corners of the mouth.

Step 4 Using the point of my 2B pencil, I build up the tone and flow of the hair. I alternate between a pencil and a stump, being careful to retain the highlights. I work on the face, using a delicate buildup of crosshatching. I draw very light, long strokes with an HB across the smooth skin of the forehead. I shade around the eye area, always following the contour of the form. I do the same for the nose, lips, cheeks, and chin, building up tone slowly. I put very subtle shading on the teeth—it is important not to make the teeth too white. I deepen the tone of the irises with a 2B, and I lift out to adjust the placement of the highlights. I move to the neck area, using heavy pressure in the cast shadow areas. I begin to shade the collar of the shirt, keeping my strokes farther apart to start developing a feel of the knit fabric. Then I use curved lines to indicate the necklace.

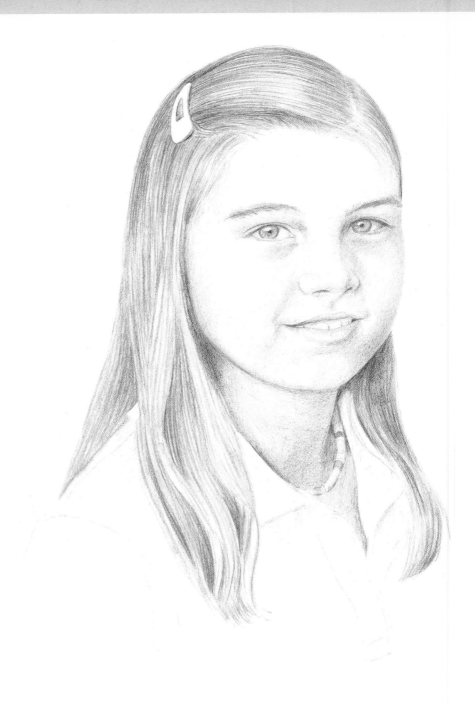

Step 5 At this point, the forms of the face are solidly established, so I begin refining. I continue building up the tone of the silky hair, using a 4B for the darks and a 2B for the lights. I deepen the shadow areas between the face and the hair that will help give depth to the face. I use a kneaded eraser to delicately lift out where tones are built up too much—at times I am doing as much work with my eraser as I am with my pencil! I deepen the eyebrows with short lines to show the variations in tone. Using radial strokes with a 2B, I darken the irises. In the detailed areas where I need a sharper point, like the folds of the eyelids or the edges of the lips, I use an HB. I continue to build up the neck, keeping it darker than the face to show the cast shadow. I shade the necklace, using separate curved strokes to indicate the heavy fibers, and fill the smooth, dark beads with heavy, circular strokes.

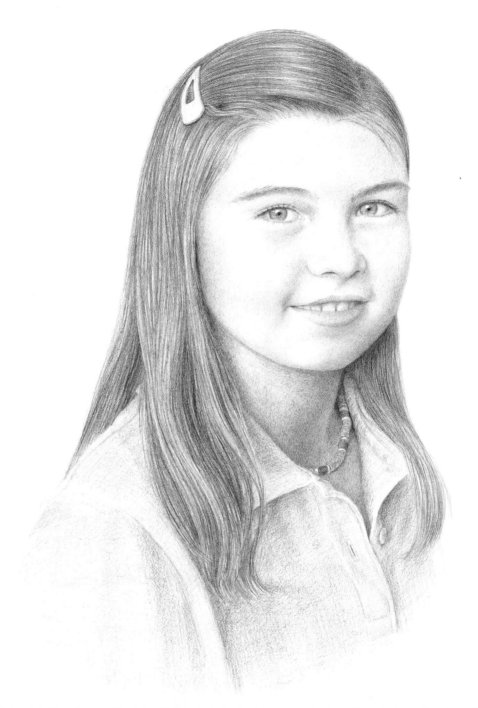

Step 6 I again build up the tone of the hair and lightly shade the plastic barrette, putting in small cast shadows with a sharp point. I continue to crosshatch the face to refine the transition between the tones, while keeping the smoothness of her skin. I still use the HB, but I also use a 2H in the lightest areas of the cheek. I deepen the upper and lower eyelashes with short lines. Then I refine the nose and mouth, using curved lines that are more prominent in the lower lip to give some texture. I deepen the tone of the gums, the lines between the teeth, and the shadow inside the mouth. For the fiber texture of the necklace, I use a soft 6B to pick up a bit of the paper's grain. Then I lift out the sharp highlights of the metal beads. Finally I work on the shirt, simulating the knit fabric with crosshatching. Then I add a line for the buttonhole and the round button.

FINAL THOUGHTS

It is with great pleasure that I share my methods of creating texture with pencil. Explore some of your own favorite subjects while employing the techniques that you have been exposed to in this book. Have the confidence to experiment with textural qualities, and remember that the most important ingredient is your passion for creating art. In time, you will find your own way to create magic with your pencil.

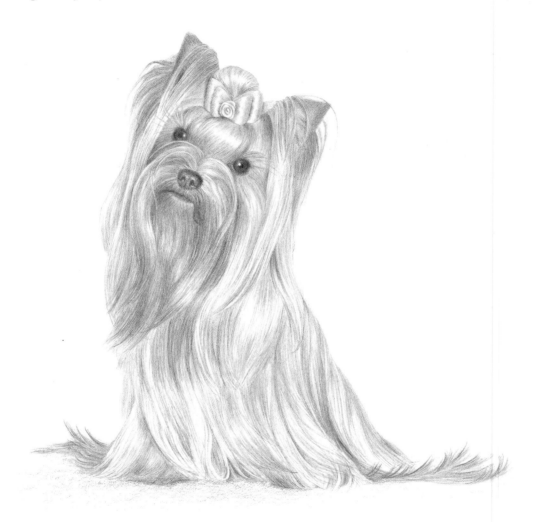